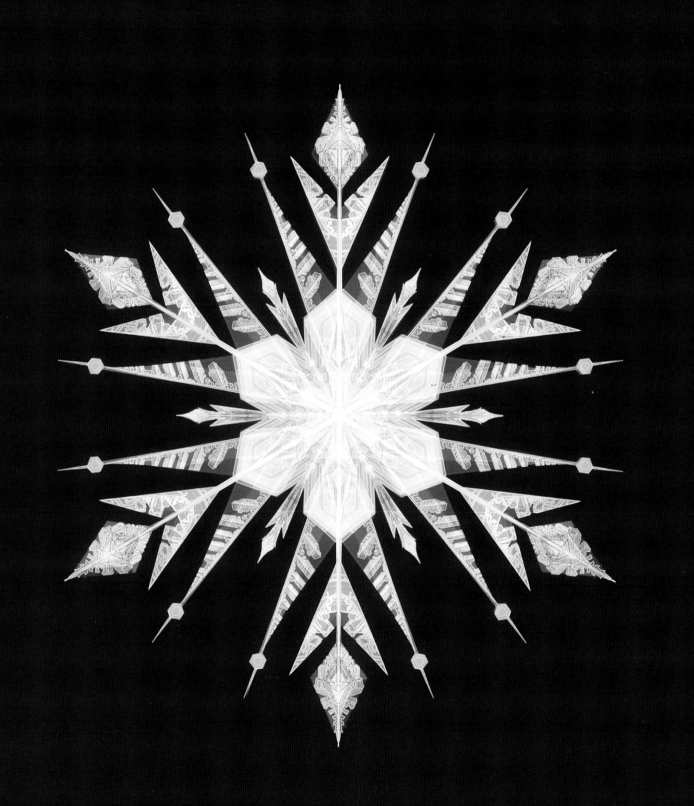

THE ART OF

By Charles Solomon
Preface by John Lasseter
Foreword by Chris Buck and Jennifer Lee

CHRONICLE BOOKS
SAN FRANCISCO

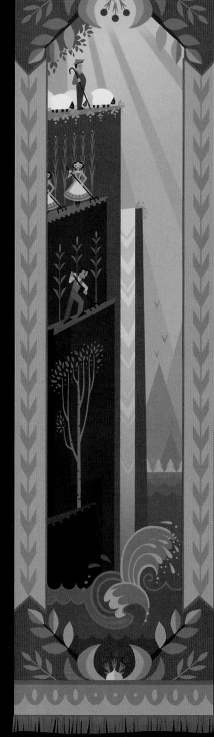

The directors wish to thank the talented artists who,
as a team, worked countless hours to craft the CG
character poses used in this book.

Library of Congress Cataloging-in-Publication Data

Solomon, Charles, 1950-
The art of Frozen / by Charles Solomon ; preface by John Lasseter ; foreword by Chris Buck
and Jennifer Lee.
pages cm
Includes bibliographical references.
ISBN 978-1-4521-1716-4
1. Frozen (Motion picture : 2013) 2. Animated films--United States--Technique.
3. Walt Disney Company. I. Title.

NC1766.U53F58 2013
791.43'34--dc23

2013016813

Manufactured in China

FSC
www.fsc.org

MIX
Paper from
responsible sources
FSC® C104723

Designed by Glen Nakasako, Smog Design, Inc.

10 9 8 7 6 5 4

Chronicle Books LLC
680 Second Street
San Francisco, California 94107
www.chroniclebooks.com

Front Cover: **Bill Schwab, Lisa Keene, Brittney Lee** | Digital
Back Cover: **David Womersley, Lisa Keene** | Digital
Front Flap: **Brittney Lee** | Digital
Back Flap: **Brittney Lee** | Digital
Endpapers: **David Womersley** | Digital
Page 1: **David Womersley, Brittney Lee** | Digital
Pages 2-3: **Jim Finn** | Digital
Pages 4-5: **Brittney Lee** | Digital

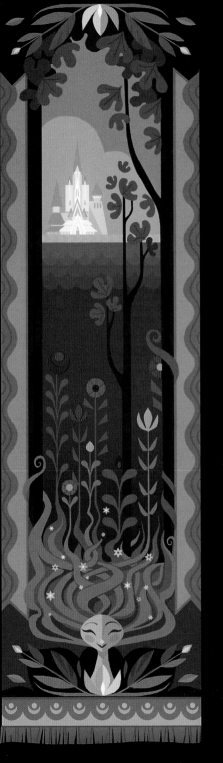

Contents

PREFACE by John Lasseter 6

FOREWORD by Chris Buck and Jennifer Lee 7

INTRODUCTION
FROM "THE SNOW QUEEN" TO FROZEN
9

PROLOGUE
A FAMILY AFFAIR
13

CHAPTER I
CORONATION
33

CHAPTER II
WILDERNESS
83

CHAPTER III
ICE PALACE
121

CHAPTER IV
RETURN TO ARENDELLE
145

BIBLIOGRAPHY 158

ACKNOWLEDGMENTS 159

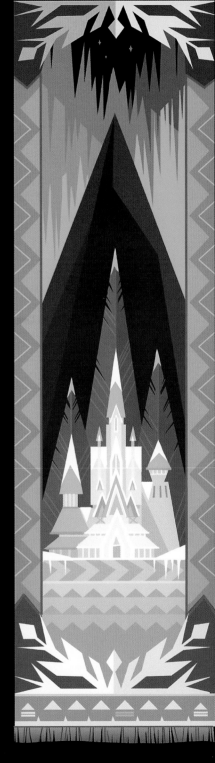

PREFACE

Back when Pixar was making *Toy Story*, we traveled down to the Disney Animation Studios regularly for meetings, and I remember being blown away by preproduction artwork for a potential film called *The Snow Queen*. There was one painting in particular by Paul Felix of the Snow Queen, riding in a sleigh through this landscape of gigantic snowflakes. At the time, the studio was concerned that contemporary audiences were not interested in sincere fairytales. But I always felt there was a way to tell these heartfelt stories for a modern audience. I'm so pleased that *Princess and the Frog* and *Tangled* have proven that people everywhere still love them.

When I was asked to come back to creatively lead the Disney Animation Studios, those beautiful images were always in the back of my head as a possible movie. But since we are a filmmaker-driven studio, it would take a filmmaking team to want to make it. Then Ed Catmull and I brought director Chris Buck back into the studio. Chris, like me, is steeped in all things Disney. He got very excited about the possibility of directing a fairytale musical based on "The Snow Queen."

The story proved difficult to develop. The original fairytale is a very episodic adventure about two young kids. But Chris and his story team had a breakthrough when they decided to make their heroine, Anna, the Snow Queen's sister. Chris then brought together the songwriters Bobby and Kristen Lopez with Jennifer Lee, who co-wrote *Wreck-It-Ralph*. Bobby and Kristen's brilliant songs really helped define the film's modern yet sincere tone. And Jenn, who agreed to join Chris as co-director, had a great take on the characters and this world full of magic and mysterious trolls. Together, they evolved the tale into *Frozen*, a unique story about two sisters that is so different from any other fairytale that Disney has ever done.

To direct the art of the film, Chris was clear from the beginning that he wanted Mike Giaimo. Mike went to Cal Arts along with Chris and me. His graphic sense of design is just phenomenal, and his use of color has always been innovative. But he had never worked in computer animation, so I was very excited to see how he would take on the medium.

First, Mike and his visual development team went on an unbelievable research trip to Norway, where they got inspiration for the architecture and costumes of the film's world. Mike was very taken by the dramatic spires of Norway's stave churches as well as heavier, medieval fortresses. He combined the architecture of both to come up with a very original castle. There, the artists also discovered rosemaling, a folk art technique of painting and embroidery. Mike incorporated this decorative art into the castle interior and costumes, but with new patterns and color choices. So while the film's detailing is grounded in tradition, it is clearly Mike's new interpretation.

But I knew Mike's talent would really shine when challenged with how to design believable frozen environments that, created by Elsa, the Snow Queen, were also magical. Early on, Mike put Elsa, once she becomes the Snow Queen, in this stunning lace cape made out of ice. That cape set the bar very high for a design sensibility for Elsa's world that was beautiful and at the same time modern. Mike was also inspired by the prism effect of ice, and used it to bring an incredibly rich color palette into this snowy world— not just blues and whites, but also pinks, oranges, and even greens—making the landscape of *Frozen* truly something we have never seen before.

Simply put, at the center of every Magic Kingdom is a castle. Fairytales are such a part of what Disney Animation is. Chris, Jenn, and Mike have found a unique way to add to this tradition. And as this book shows, the work of the artists throughout *Frozen*'s design process has been nothing short of breathtaking.
—John Lasseter

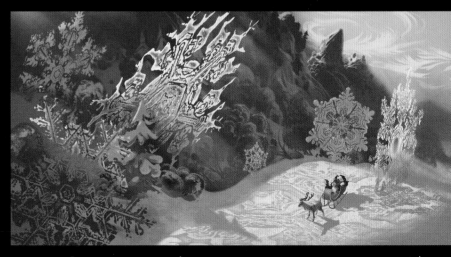

Paul Felix | Digital

FOREWORD

When our art director Michael Giaimo first read the script for *Frozen*, his immediate reaction was, "This is a big movie." From a story perspective, that's what we were going for, but at the time we were so focused on the details that we hadn't yet grasped the visual challenges that such a "big movie" brought. Luckily, from the very beginning, Mike had a strong sense of what it would take to bring this epic landscape to life, and thankfully, he was inspired by the undertaking.

For example, we've got more than our fair share of snow in this film. But thanks to Mike and our visual development team, there is so much more color than anyone could have imagined. White, as Mike says, is a blank canvas upon which to build. From the warm peach and yellow tones at sunrise, the deep pinks and blues cast at sunset, to the rich indigos and purples caught in the moonlight, no scene suffers from a lack of color. And then there are the costumes, inspired by the rich, colorful Scandinavian bunads with their thick fabrics and rosemaling designs. The sisters both wear several gorgeous gowns. Elsa even wears one made of ice. But one of the most fun design challenges was working with the team to come up with the outfit for our ice-harvesting, mountain man, Kristoff. The design of his heavy tunic, pants, and shoes grew out of researching the Sami people, an ancient, indigenous group that still lives in the arctic area.

All of the research on this film helped us not only find the details of this world but also the spirit of this story. The visual development team went to Norway, and a group of us also went to Quebec City to see the ice hotel, a giant palace built entirely out of ice every year. (John Lasseter insisted we stay there, but we didn't. Those icy beds, while beautiful, didn't look so comfortable!) We timed our visit to coincide with Quebec's winter carnival, a two-week festival with dogsled races, parades, and amazing snow sculptures. The whole community was out on the streets in the middle of February. What really struck us was how the cold weather didn't stop the people from living their lives outside. In fact, the weather brought the whole city together to celebrate the cold. That experience inspired us to make sure that *Frozen* celebrates winter overall.

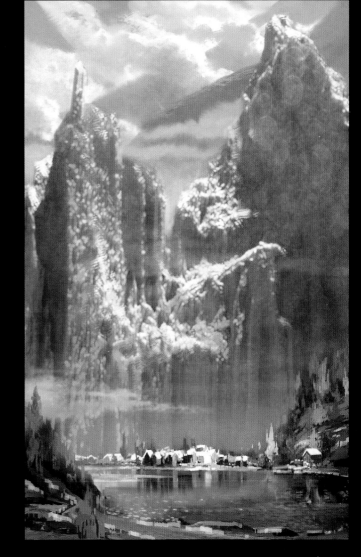

Lisa Keene | Digital

Mike was right. The scope of this film was a big undertaking. Alone, it would have felt daunting. But our amazing crew all helped us, character by character, set by set, and costume by costume, to pull off the seemingly impossible. We wanted the look of this film to be so unique and special that one could pull any frame and know it could only have come from *Frozen*. Thanks to Mike and all the artists, we might just have done it. We are very excited that we have the chance in this book to show off their beautiful work.

—Chris Buck and Jennifer Lee

FROM "THE SNOW QUEEN" TO FROZEN

The fairy tale of film—created with the magic of animation—is the modern equivalent of the great parables of the Middle Ages. Creation is the word. Not adaptation. Not version. We can translate the ancient fairy tale into its modern equivalent without losing the lovely patina of its once-upon-a-time quality . . . We have proved that the age-old entertainment based on the classic fairy tale recognizes no young, no old.
—Walt Disney

Walt Disney may well have felt a personal bond with Hans Christian Andersen. Both men rose from humble backgrounds to attain wealth and international fame as storytellers. Both men produced remarkable bodies of work that speak to children and adults alike.

During the '30s and early '40s, artists at the Disney Studio explored the possibilities of animating many of Andersen's fairy tales. *The Ugly Duckling* (1931) was one of the studio's first efforts to imbue a cartoon character with serious emotions. Warner Bros. director Chuck Jones praised Disney's second, Oscar-winning adaptation of *The Ugly Duckling* (1939) as "one of the best short subjects ever made." Artists also developed versions of "The Emperor's New Clothes," "The Emperor's Nightingale," "Through the Picture Frame," "The Little Fir Tree" "The Steadfast Tin Soldier," "The Little Mermaid," and "The Snow Queen."

In April, 1938, researcher Mary Goodrich presented a synopsis of "The Snow Queen," listing its basic theme as "regeneration through faith." Two years later, in a highly detailed, somewhat rambling discussion, Norwegian-born researcher Karl Berggrav complained, "This story rounds off everything nicely and ties up loose ends, but it is very uninteresting and just fades out into nothing, or worse than nothing, banality. It is hard to make good animation out of it."

Much of this research was done for a proposed live action/animation biography of Andersen. Discussions about either a biographical film or a feature-length collection of Andersen's fairy tales began in late 1937, shortly before *Snow White and the Seven Dwarfs* was released. Samuel Goldwyn was also interested in Andersen's life, and in March 1940, Walt Disney suggested a co-production, with his studio animating the fairy tales and Goldwyn providing the live action sequences. Development continued into 1942, but the project was shelved when Disney became too busy producing military training films, educational shorts for the Office of Inter-American Affairs and was never made.

A new generation of Disney artists revisited Andersen's stories decades later. John Musker and Ron Clements transformed the "The Little Mermaid" into an upbeat musical that signaled the renaissance of Disney animation in 1989. A version of "The Steadfast Tin Soldier" was included in *Fantasia 2000*, and *Lion King* director Roger Allers adapted "The Little Match Girl" into a short in 2006.

Initially published in 1845, "The Snow Queen" is one of Andersen's longest tales, although he wrote it in just five days. When the magic mirror created by an evil troll shatters, shards lodge in the eye and heart of a little boy named Kai. They make him forget his best friend, Gerda, and fly away with the icily beautiful Snow Queen. Gerda embarks on a long and perilous journey to the remote palace: Her kisses melt the mirror-shards, freeing Kai from the Queen's spell and enabling him to return home with his beloved friend.

Although "The Snow Queen" has been highly praised by critics and scholars, it is a protracted, episodic, and rather bleak tale. Yet Andersen's vision of an elegant queen ruling over a frozen kingdom captured the imagination of such great illustrators as Edmund DuLac, Arthur Rackham and Kay Nielsen. Lev Atamanov directed a heavily rotoscoped animated feature in the USSR in 1957, which was released in the United States two years later with the voices of Sandra Dee and Tommy Kirk.

Notes, drafts, and sketches for several versions of "The Snow Queen" created between 2000 and 2002 have been preserved in the Disney Studios Animation Research Library. All of them discard the troll and the mirror, requiring the filmmakers to find a motive for Kai to leave. In one version set in Iceland, he goes to sea on a whaling ship to impress Erica (Gerda), and the title character rides away on an orca. In other treatments, the artists experimented with comic side characters

Brittney Lee | Digital

Brittney Lee | Digital

(polar bears, owls, penguins, walruses, snowmen) and considered various curses and spells that would somehow bring Kai to the Queen. In one very strange outline, Gerda becomes Greta, a devious gold digger, and Kai marries the Snow Queen.

Much of the artwork for these versions is strikingly diverse and often beautiful. But no one found a way to turn the minimally defined characters and episodic plot into a compelling narrative.

"The Snow Queen" began its metamorphosis into *Frozen* when Disney/Pixar chief creative officer John Lasseter contacted his friend Chris Buck about returning to the studio. Buck had been working at Sony, where he'd recently directed *Surf's Up* (2007). "I pitched several ideas to John, and 'The Snow Queen' was one that he'd been interested in for a while," says Buck. "I pitched a musical version of it that he seemed excited by. So we started developing that project. This was back in 2008, around September."

The filmmakers agree the key to the creation of *Frozen* was the decision to abandon Andersen's focus on Gerda's epic journey and keep only the distant, beautiful Queen of the title. "We made it a cleaner journey, as opposed to being as episodic as the book," says Buck. "We basically made our own: our leads are now adults; in the book it's two children."

"It wasn't until we came up with the idea that the heroine and villain were sisters with a shared past that we unlocked a story," adds producer Peter Del Vecho. "We did a version where the Snow Queen was the villain, but we wanted to end with them reunited, and it was very hard to redeem her at the end. We decided on an adventure about two people who initially misunderstand each other; it allows for the bonding at the end."

"When I was brought on, they had already moved away from 'The Snow Queen,'" continues director Jennifer Lee. "I had given notes and comments during the development process, so I knew the plot was shifting. At the heart of the new story were the sisters: There was something very interesting about the idea of one sister who has a superpower—or an affliction—and one who's ignored because her sister's taking up all the energy in the room."

"It's extremely challenging to make traditional fairy tales work as three-act feature films, and make them believable for today's audiences," concludes Lasseter. "We looked at the story and chose some elements, then put it away and started developing a story we wanted to tell. So it's really an original story loosely based on 'The Snow Queen.'"

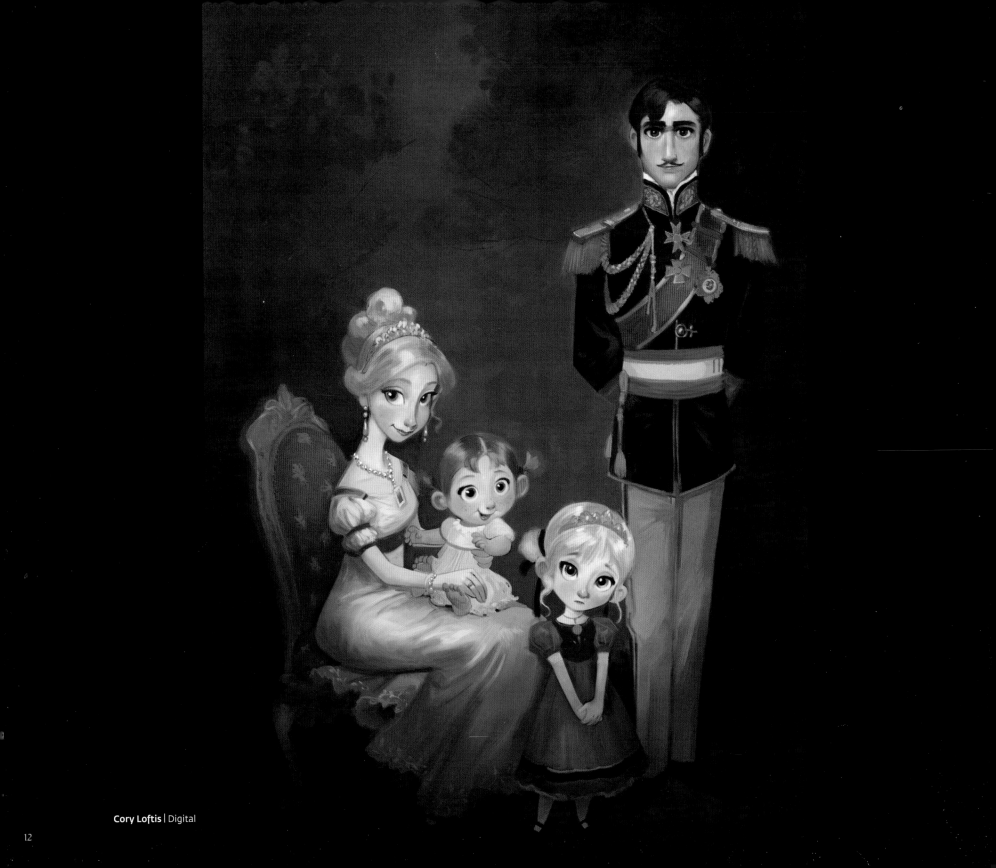

Cory Loftis | Digital

A FAMILY AFFAIR

In story, you have to open yourself up emotionally in a way most jobs don't ask you to. You pull from your life experiences—all your jokes and the things that hurt—and put them into a scene. You've got to believe in it and you've got to sell it. You have to hear other points of view and take them seriously. That separates story artists from other people—we have to be able to survive that.
—Chris Williams, story artist

Claire Keane | Pencil

As small children Elsa and Anna, the princesses of Arendelle, were loving sisters. They played together under the watchful eyes of their royal parents until the day Elsa accidentally hurt her sister with her power to create ice and cold. The King and Queen forbade Elsa to see Anna, and the life the girls had shared became a series of closed doors—doors they both wanted to open.

Elsa knew they had been separated to protect Anna, but Anna didn't understand why her sister said no whenever she suggested doing something together. After the deaths of their parents, the sisters grew further apart.

The artists agree that the key to "cracking" the story was the decision to focus on the bond between Anna and Elsa. Instead of a standard princess finding her prince story, the film became an exploration of the special bond sisters share, a bond that can transcend years of separation and misunderstanding. Except for *Lilo and Stitch* (2002), stories about sisters are rare in American animation. Ariel in *The Little Mermaid* and Merida in *Brave* have little interaction with their siblings.

Jean Gilllmore | Pen

Claire Keane | Pen

"At first, I didn't want to work on a princess movie," says head of story Paul Briggs. "But once I got into it, I saw, 'This isn't a princess movie, this is a sibling story.' And I know sisters: I have four. Every movie goes through stages where it tells you what it wants to be. Once you find it, things become clear, and the characters start clicking."

"Elsa was going to be the complete antagonist," explains director Jennifer Lee. "They kept calling her the 'villain.' But there came a point where we said, 'We can't use that word anymore.' You care about someone who's been forced to hide who they are. Elsa's not a villain, she just makes some bad choices because she's in a very difficult situation.

"John Lasseter always says you have to understand why every character does what they do, whether they're bad guys or good guys," she continues. "You have to understand their philosophy, even if you don't believe in it. Elsa became more the yin to Anna's yang, as opposed to the bad guy. It's richer, and their relationship is more interesting."

To gain a better understanding of their relationship, the Disney artists held what they called the Sister Summit. "I grew up with one sister, but I only have boys, and Chris Buck only has sons," says chief creative officer of Pixar and Disney Feature Animation John Lasseter. "It was really important to be authentic. So we brought together women from all over Disney animation who grew up with sisters, and they start talking about their relationships. It was fascinating."

"We'd talk about classic fairy tales and princess movies, but those stories are dominated by this sense of romance; no one's focused on the relationship between siblings in them." says Lee. "They brought all of us who have sisters into a room and we shared the real conflict, real angst, and real heart. We had a lot of fun exploring what sisters do—from fighting over clothes to deeper issues like watching your sister struggle and not knowing how to help."

"We didn't want the boy to drive Anna and Elsa apart or save the day," she adds. "It's about the two sisters saving each other; it's their broken relationship, and how they repair it."

A strong story will carry weak animation, but the most polished animation can't save a weak story. Artists who worked on beloved films, from *Snow White and the Seven Dwarfs* to *The Iron Giant*, complain about technical flaws audiences don't notice because they're involved with the characters. Crafting a solid story is a demanding process that requires thousands of drawings and tens of thousands of words.

"When John took over as the chief creative officer of the studio, he brought a lot of experience from Pixar that he wanted to instill in us. He took us to Pixar to watch the 'Brain Trust' in action," explains producer Peter Del Vecho, referring to the group of filmmakers at Pixar who review pitches and films in progress. "Although they're brutal in the notes sessions, there's a sense that it's all to make the film better. Everyone remains friends, though the discussions can get quite heated. We speak up when we think something can be stronger.

"We recently came out of a retreat for *Frozen*," Del Vecho continues. "We had a number of directors and John and Ed Catmull there, trying to make the movie as strong as it can be. It was great, but it's a very difficult process. The first day is taking the engine out of the car and laying all the pieces out in the driveway: 'Oh my God, how are we ever going to get it back together?' But the second day, you reconstruct it, and it's better than when you started."

101 Dalmatians (1961) was the first Disney animated feature to begin as a screenplay, written by Bill Peet. Since then, more and more animated films have had screenplays. "I come from a writing background," says Lee. "The story artists use images and I use words, but we're both seeing the scene in our heads. For me, the best thing to do is to write it, even if it's rough—board it, look at it, and then build off it."

Storytelling is pretty much the same regardless of the medium, but the amount of multidiscipline collaboration needed on a CG movie is greater. There are more people involved in each decision, because we have people dealing with hair and cloth and lighting. Any one decision can impact something you didn't realize could be impacted.
—Peter Del Vecho, producer

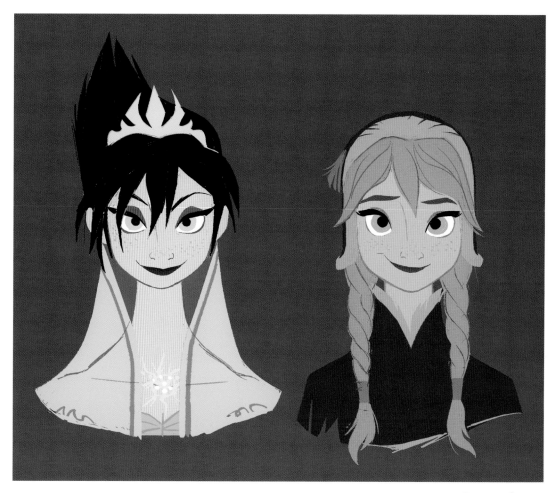

Bill Schwab | Digital

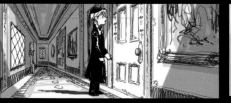 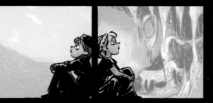 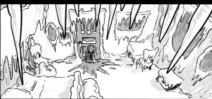

Paul Briggs, Steve Anderson, Chris Williams, Normand Lemay, Fawn Veerasunthorn | Digital

Story artist Jeff Ranjo explains: "Before we start boarding, the writer may take a pass. We'll read that first pass with the whole story crew in the room and throw in ideas. The second pass will be the first for the artist, who'll take the best ideas and run with them. We're here to help put the director's vision up there, and lend our personal taste to it."

"Generally, everybody gets one sequence; a lot of times it's issued on Monday or Tuesday, and you try to show something by Friday," adds story artist John Ripa. "You spend the week working on your sequence, then we all come together and pitch. People tend to get typecast. I get a lot of drama, subtle acting, or big action. I don't get a lot of comedy. I come in every Monday, 'I hope I get a comedy sequence!' And they say, 'Here—the character has died!'"

As they struggle to turn words and ideas into images, the artists draw on personal experiences, striving to get the maximum emotional and visual power into their boards, which will be drawn, pitched, discussed, and redrawn many times. Chris Williams reflects: "Most of the other disciplines are more of a craft. They're things you can learn and develop over time. In story, you're asked to give so much of what you are personally."

Because the story artists work so closely together, they share an obvious bond. They bounce off each others' words and riff on each others' ideas.

"The first time you pitch something or voice your opinion is very nerve-racking," says story artist Normand Lemay. "But knowing everyone will be as nervous when they're pitching their sequence is comforting. You need that safe room environment. That doesn't mean that we accept everything. If it's not funny, we won't laugh. But we'll applaud the effort."

Normand Lemay | Digital

Back in the old days on paper, you could get away with fewer sketches. When you're doing it digitally, everything has to be up on the screen. You put more poses in to make it more like an animatic. It has to play on the screen, it has to move, and it has to cut well.
—Jeff Ranjo, story artist

Paul Briggs | Digital

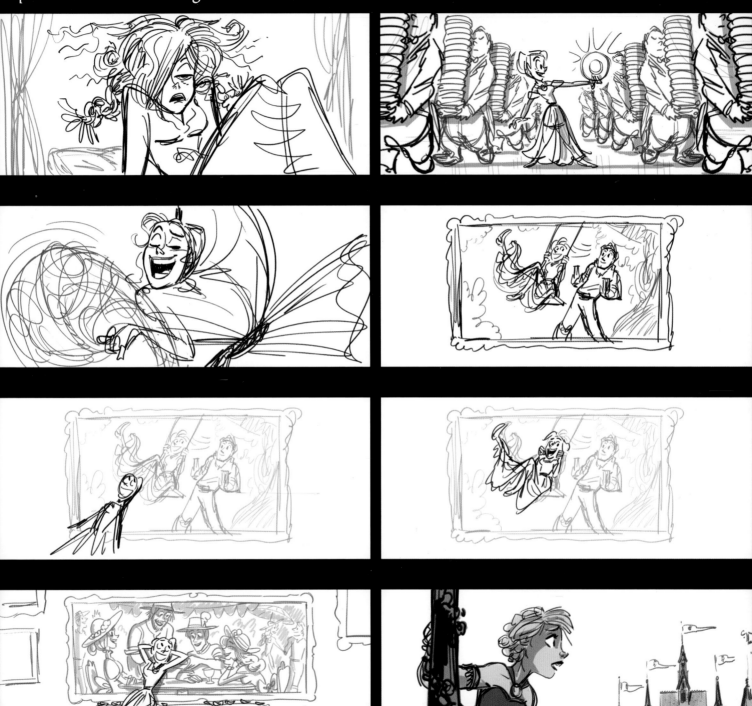

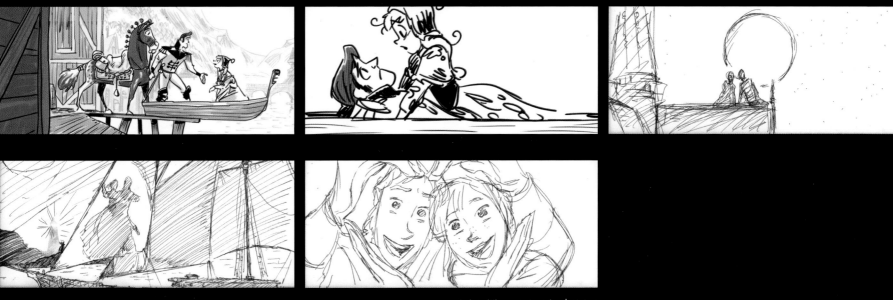

Chris Williams, John Ripa | Digital

"When you think about the story, you pull from your life experiences, you put that in front of everybody, and talk about it," adds story artist Fawn Veerasunthorn. "You feel very vulnerable."

"You really feel vulnerable," agrees Ranjo. "We put this stuff up there, then everybody tears it down. It's all professional. Nobody's attacking you. Everybody wants to make the strongest film they can. The more input you get, the more you tear it down and build it back up, the stronger it gets. That's story."

The story artists may feel vulnerable when they're pitching boards, but they agree nothing is more satisfying than a lively story session, when the crew is hitting the correct beats and "plussing" ideas. Head of story Paul Briggs says, "It's so much fun to be in those meetings where John Lasseter becomes just another one of the story guys. When he gets really excited, and everybody's just as excited and attacking the story, those are the absolute best days to work here."

In recent years, American animated films have grown increasingly talky, with sitcom one-liners replacing the minimal dialogue of earlier films. Yet the artists speak with greatest admiration of the classic Disney features and the work of Hayao Miyazaki, both of which convey complex emotions without words.

"I've heard it often said in the story room that people remember things more if you do it visually than just words," says Ripa. "Words sometimes go in one ear and out the other. But when audiences see it, they experience it. It connects; it lands. We have the freedom to pull back on dialogue if we can find a way to do it visually."

"You hear that mantra constantly: 'Can we do it without dialogue?'" agrees Williams. "But we don't always listen to our own advice. The story reels tend to want dialogue, but the animation tends to not want it. That's one of Lasseter's gifts: he can see the finished movie in his head when he's looking at the story reels. So some of those moments survive."

Devised at the Walt Disney Studio in 1933, the storyboard consisted of drawings and captions pinned to large sheets of corkboard. An artist would present his boards, explaining or performing the characters' actions, and some individuals were known as "great presenters." In recent years, story artists have begun scanning their drawings into a computer and presenting them in sequence as mini-movies.

"Pitching a storyboard is an art form unto itself," says Lasseter. "Joe Ranft was the master at it. But so much of what was working was really Joe's performance. When you got into the story reel, you'd start seeing things that weren't quite

working, and you'd have to refine it. These digital tools help us get to how a sequence is working in the movie faster. They've elevated the quality of our story reels and helped us understand how the story is working more quickly."

Now that the majority of story artists draw on computers, it makes sending material to editorial that much easier.

"We create the entire movie in rough form before a single frame of animation is done," says lead editor Jeff Draheim. "We work from the very beginning with the story crew putting together rough storyboards and temp sound effects, temp music, scratch dialogue, just to see how it plays."

The editor and the story crew have to work closely together as the film goes through its many permutations and refinements. "I've been with Disney for eighteen years and know all the board artists on this show," Draheim continues. "If I come to them and say, 'It would be great if I could go to a wide shot before we cut to the close-up,' they trust me enough to say, 'No problem.'"

As the development of the story progresses, the artists work to make the fairy tale elements feel magical yet believable and appealing to modern viewers. "I think they did a good job of making *Tangled* feel contemporary," Buck concludes, speaking of the 2010 Disney animation that took off from the "Rapunzel" story. "Our goal is to give the story a contemporary sense when it comes to who the characters are. Fairy tales are such wonderful stories; they speak to any generation."

Sequence 8.0 — Sisters Split

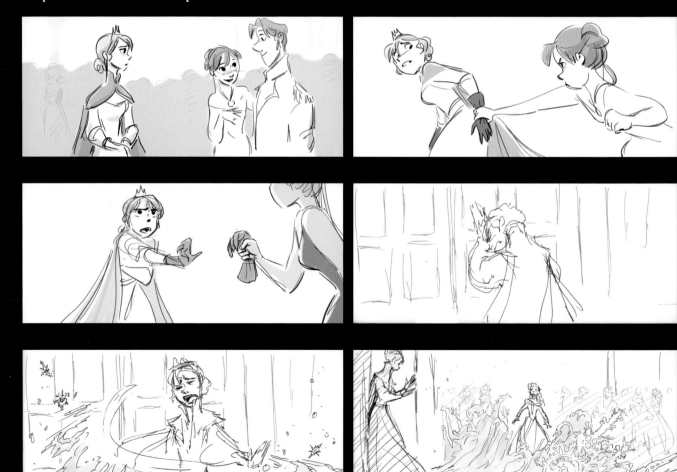

Sequence 10.0 — Elsa's Song

Paul Briggs | Digital

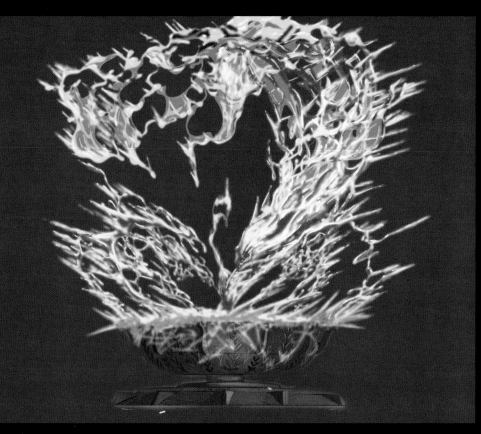

Dan Lund | Digital

Dan Lund | Digital

Dan Lund | Digital

Dan Lund | Digital

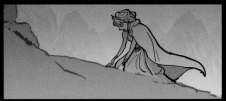
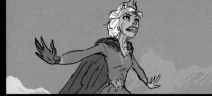
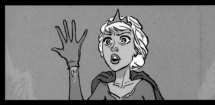

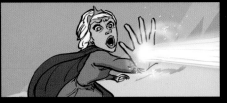

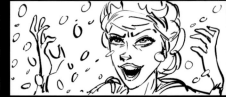

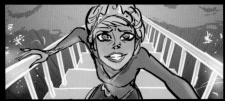
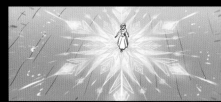
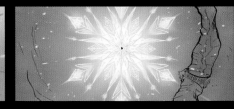

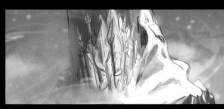

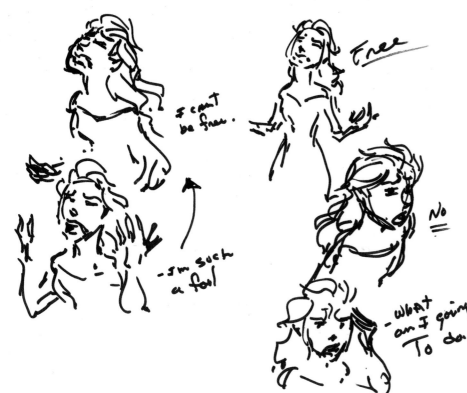

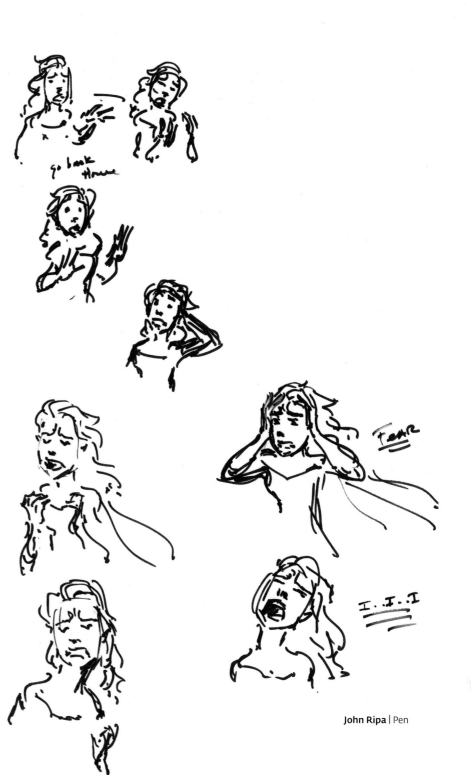

I'll never forget John Ripa sketching Elsa, while watching Idina Menzel sing in the studio. He captured Idina's passion and used it to bring Elsa to life.
—Jennifer Lee, director

John Ripa | Pen

Chris Williams | Digital

What's interesting for me as a woman coming in is,
I was never treated like a woman coming in. The
culture and storytelling are opening up: Women
characters can be stronger and feistier and drive
things. Disney's really embracing it, particularly John.

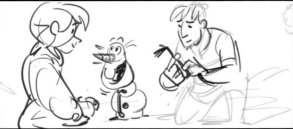

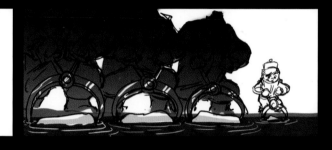

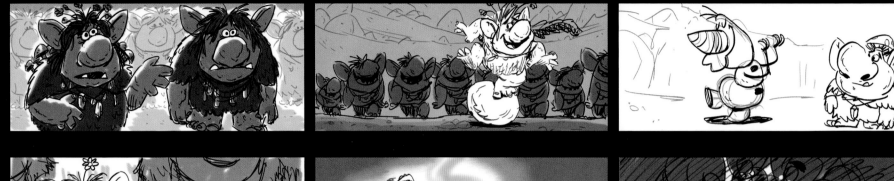

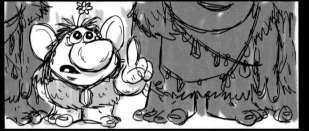

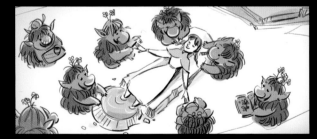
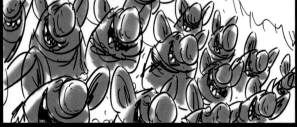
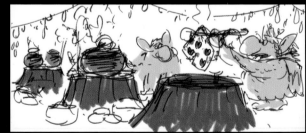

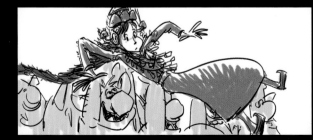

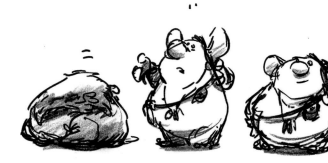

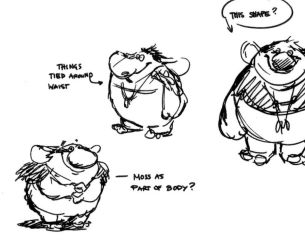

THIS SHAPE?

THINGS TIED AROUND WAIST

— MOSS AS PART OF BODY?

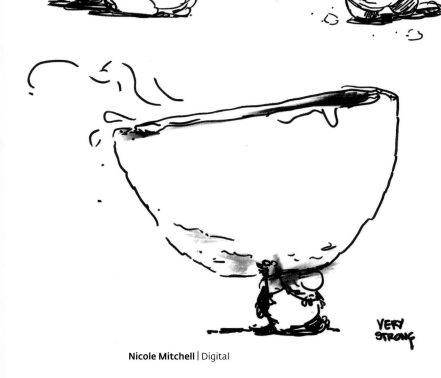

VERY STRONG

Nicole Mitchell did these sketches of these roly-poly trolls covered in moss and mushrooms. They were so appealing and really felt like fjord rocks come to life. Seeing them we knew we'd found our trolls.
—Chris Buck, director

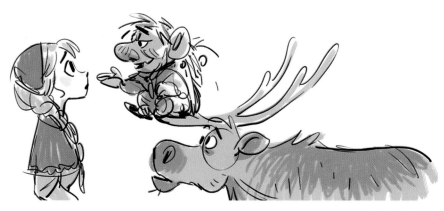

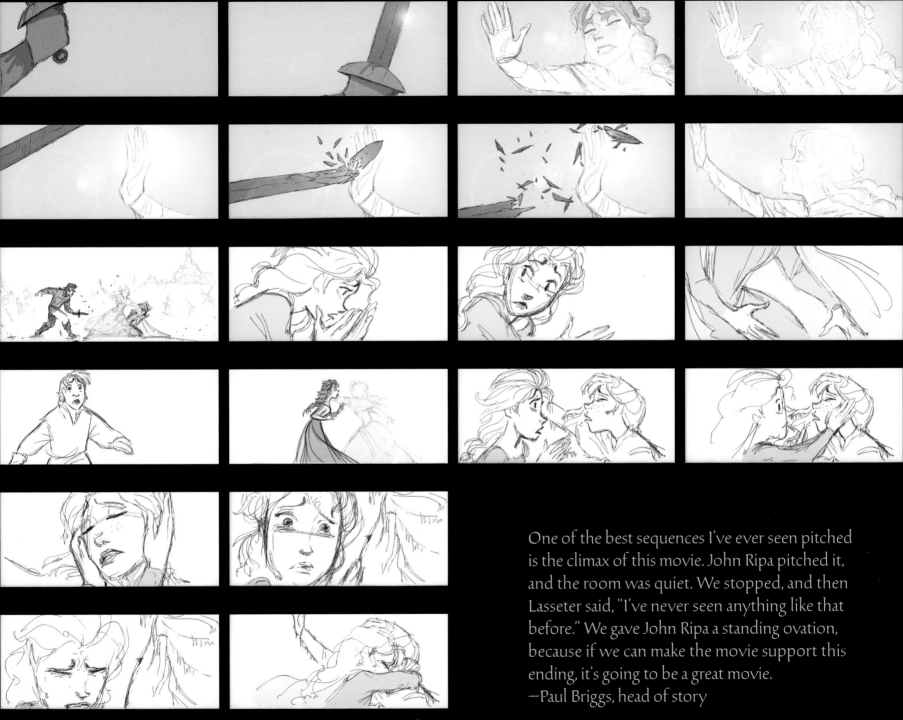

One of the best sequences I've ever seen pitched
is the climax of this movie. John Ripa pitched it,
and the room was quiet. We stopped, and then
Lasseter said, "I've never seen anything like that
before." We gave John Ripa a standing ovation,
because if we can make the movie support this
ending, it's going to be a great movie.
—Paul Briggs, head of story

John Ripa | Digital

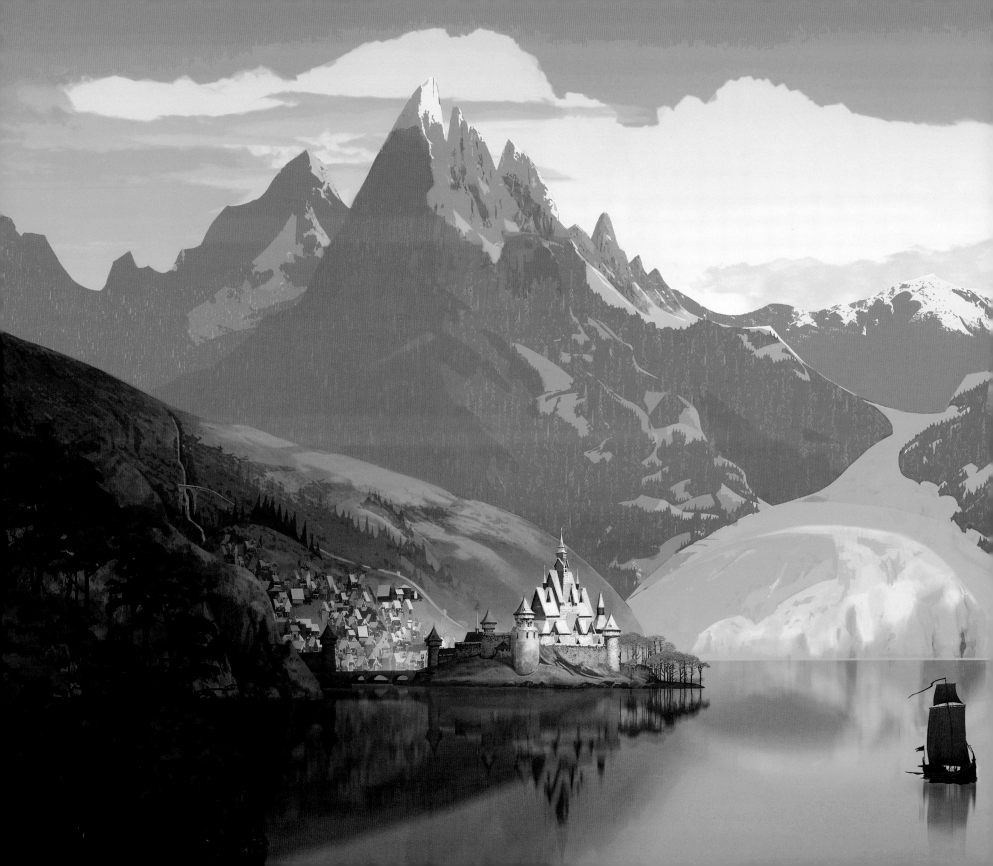

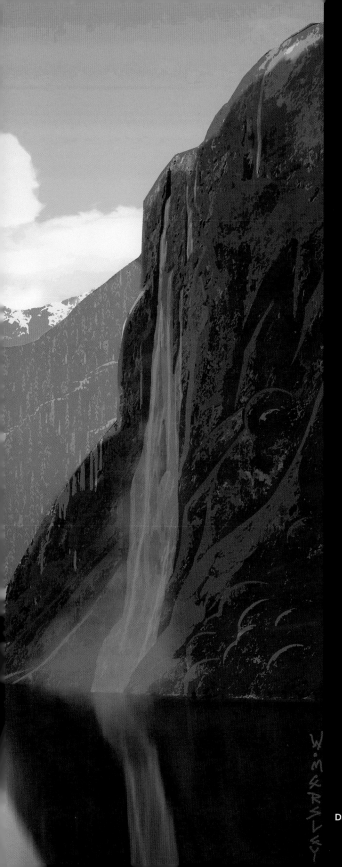

David Womersley | Digital

CORONATION

One of the first people I recruited was Michael Giaimo. I wanted to do something very strong and shape-oriented. I knew Mike's amazing sense of shape and design would be great to take to CG level. I wanted somebody who pushes the boundaries on both color and shape. If you don't push those boundaries in CG, the results can look too realistic. You don't feel you've caricatured it.
—Chris Buck, director

All of Arendelle eagerly awaited the coronation of Princess Elsa. Inside the castle, preparations were underway for the reception of foreign ambassadors and formal banquets. In the town, people were planning celebrations and buying delicacies. Dresses were being fitted, medals were being polished, entertainers were rehearsing. The entire kingdom was in motion.

Director Chris Buck knew he wanted to use more stylized designs in the tradition of 101 Dalmatians, Sleeping Beauty, the classic Disney Little Golden Books, and midcentury American design. No one had done more to popularize that style than Michael Giaimo, both as an artist and a teacher. He, Buck, and John Lasseter were old friends, going back to their student days at CalArts.

"Michael Giaimo's sense of color and design are just exquisite. I thought it was an inspired choice to get him back to Disney," says Lasseter. "The mark of a great production designer is he creates preproduction art that inspires ideas the storytellers would not have had without it. The preproduction work inspired me: I kept looking at it and thinking this would be an amazing world to do as a computer-animated film."

When Buck approached him about working on the film, Giaimo's reaction was "a little caution mixed with burning desire." He insisted on doing a painting, testing some design elements and color theory, which "Chris responded really well to."

"I thought this would be a great opportunity to create a beautiful environment as well as a stunning CG (computer graphics) costume film where the design conceits of the environment and characters talk to each other and share a mutual design language," Giaimo continues. "I found this potential to be one of the most intriguing aspects of *Frozen*. When I started down that road I was told that this level of complexity and attention to detail from costume to character had never been done before in a CG film, but everyone was game. Sometimes it's good to be a little naïve!"

Early in the production, it was decided that Arendelle would be based on Scandinavian designs, as *Sleeping Beauty* had been inspired by French illuminated manuscripts. Giaimo, along with assistant art director Lisa Keene, production designer David Womersley, and some of the other artists, made a trip to Solvang, the Danish village in Central California. After meeting with historians who explained the specificity of Scandinavian cultures, they realized they couldn't pick and choose among those proud individual traditions, and they decided to focus on Norway.

"I always insist on doing tremendous amounts of research, and part of it is visual research," states Lasseter. "A group of artists went to Norway and came back with beautiful imagery."

Mohit Kallianpur | Photograph

Geirangerfiord, Norway

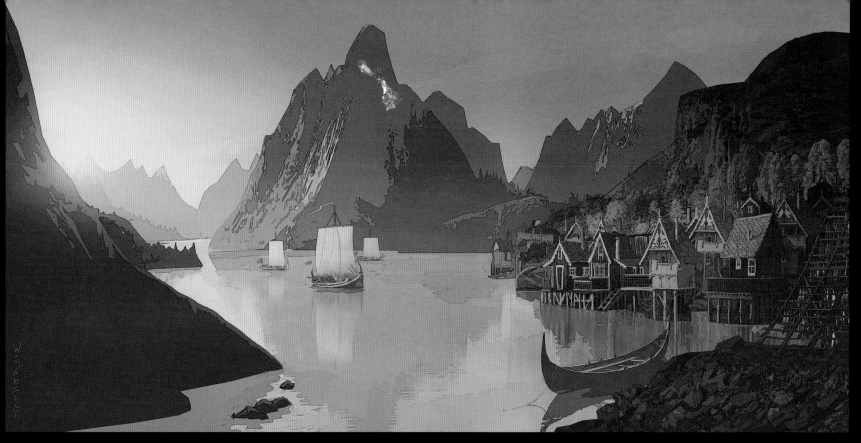

David Womersley | Digital

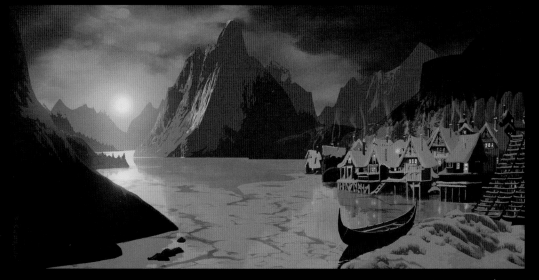

David Womersley | Digital

David Womersley has done such a beautiful job of realizing this kingdom; it's pushed, and yet it's beautiful. As much as I love design, I never want design just for design's sake. David understands how to push, but only as far as what's reasonable in a believable world.

—Michael Giaimo, art director

We noticed in the older parts of Balestrand nothing is parallel. Over the decades, things have settled. We're bringing that into our movie: Everything in the town isn't perfectly symmetrical, which works really well with the caricatured characters.
—Mohit Kallianpur, director of look and lighting

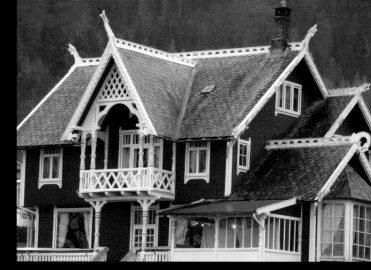

Balestrand, Norway **Mohit Kallianpur** | Photograph

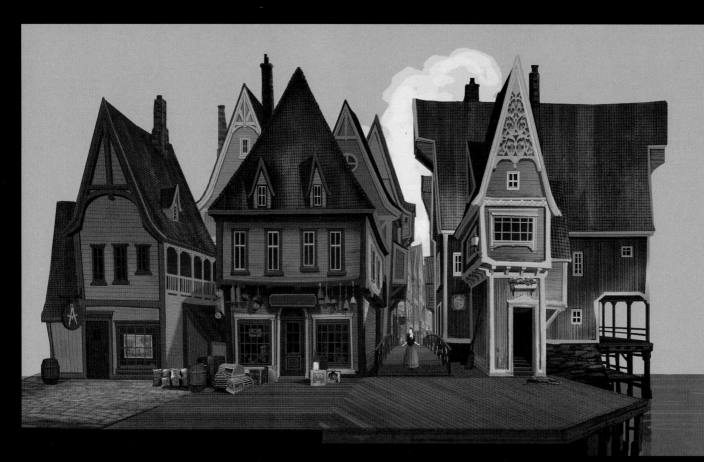

James Finch | Digital

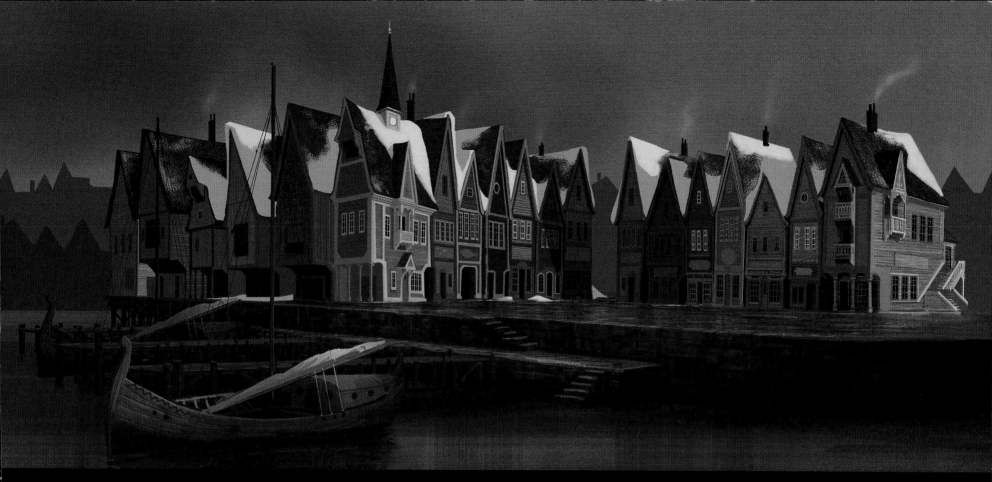

James Finch | Digital

Michael Giaimo | Acrylic

There are things you can't get out of a book or off Google or wherever you get your reference. The things we look for are not the things you'd find anyway—a picture of a crossbeam, how a structure was built: there were no modern tools, so it's all hand-cut wood. How things are built, how they look, how they're constructed, how they're painted.
—Jim Finn, visual development artist

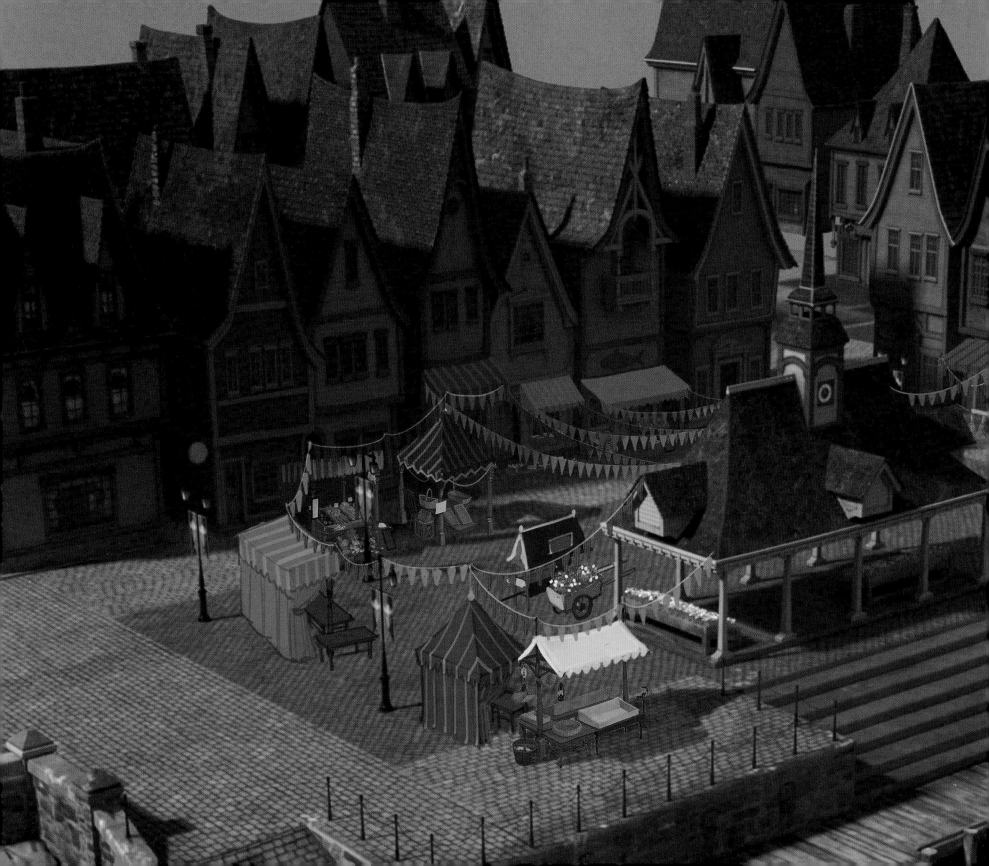

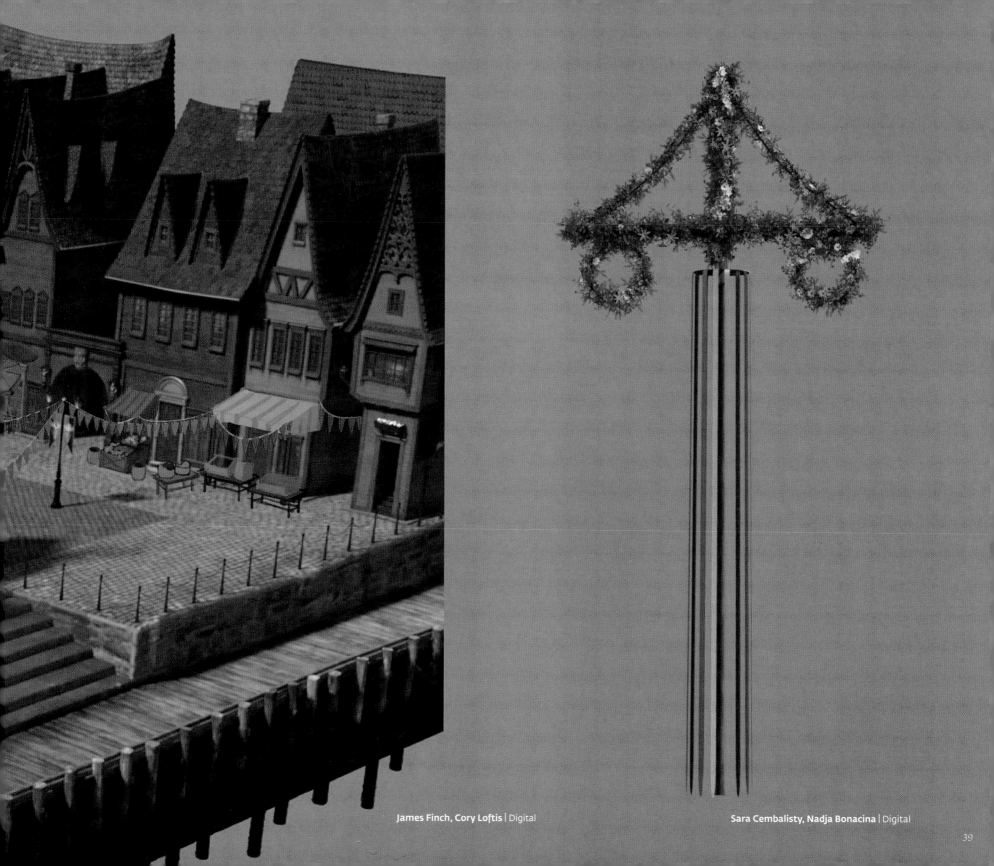

James Finch, Cory Loftis | Digital

Sara Cembalisty, Nadja Bonacina | Digital

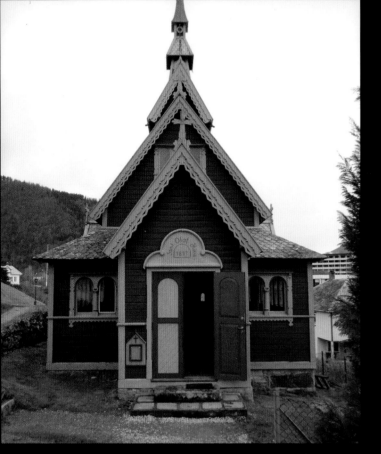

St. Olav's, Balestrand **David Womersley** | Photograph

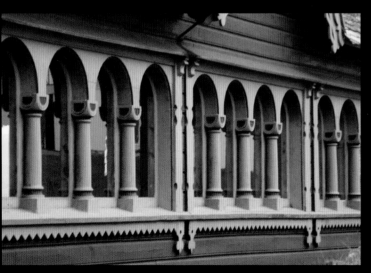

St. Olav's, Balestrand **Michael Giaimo** | Photograph

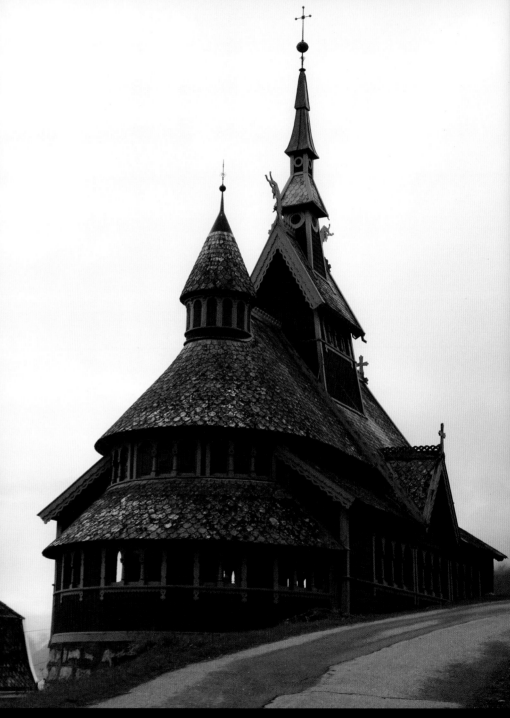

The charming Norwegian village of Balestrand provided not only the
inspiration for the chapel where Elsa is coronated but also provided
many architectural motifs for the Arendelle Kingdom as well.

Michael Giaimo | Photograph

The Chapel

screen
alter **pulpitt** **kneeler** **post** **pews**
doors
rug
side table
chair **steps** **windows**

Arendelle village is based on the "dragonstil" style of architecture, which was a late nineteenth century nostalgic take, blending the Victorian aesthetic with Norwegian rustic design.

Jim Finn | Digital

The Chapel

Side view

Back view **Front view**

The artists were particularly struck by the Norwegian stave churches, flam-
boyant wooden structures that date back to the twelfth century. Giaimo praises
Womersley's design for the castle of Arendelle, which "looks like a castle, but its roof
line and detailing riff on a stave church. No one else could have pushed the shapes
inspired by the stave churches the way David did. When I saw the castle taking
shape, I knew how far we could push the characters and marry them to this world."

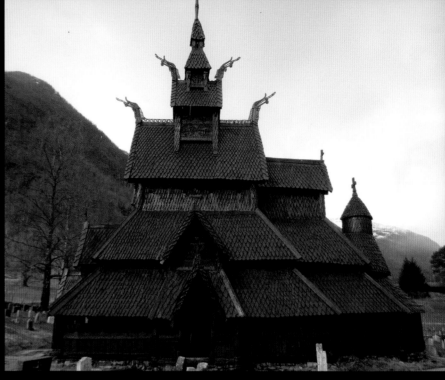

Borgund Stave Church, Norway **David Womersley** | Photograph

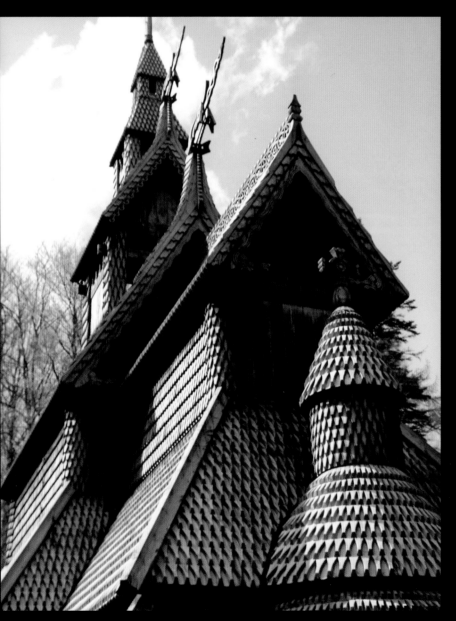

Michael Giaimo | Photograph

David Womersley | Digital

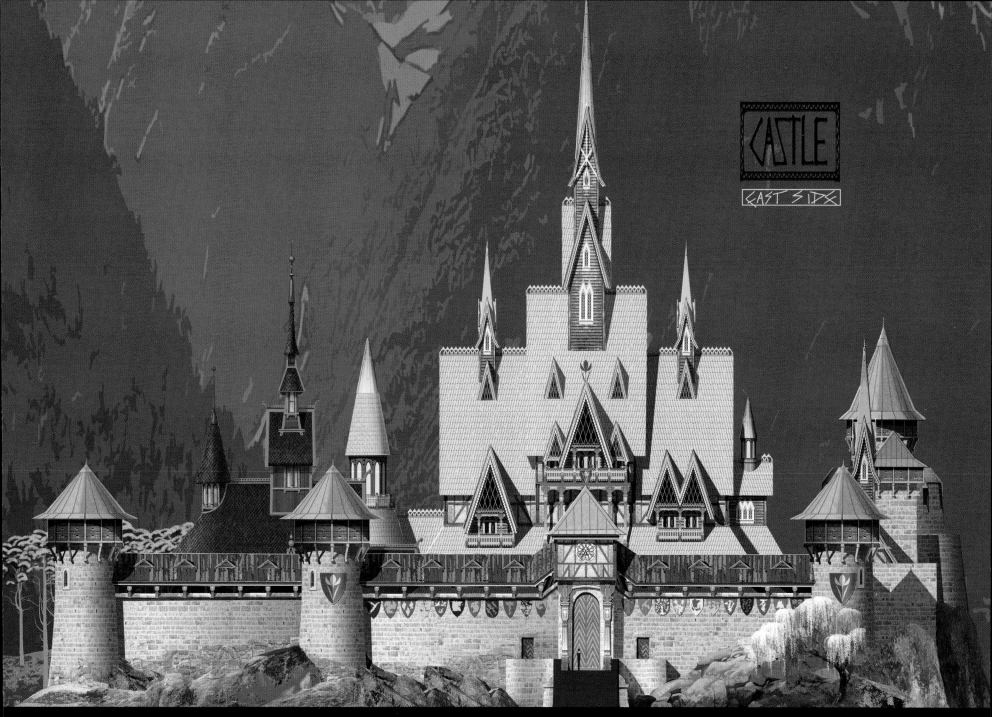

CASTLE

EAST SIDE

Originally the castle of Arendelle was to be designed using only selected motifs from the stave church. John Lasseter encouraged the artists to "go all the way" and celebrate holistically the unique qualities of these grand structures.

David Womersley | Digital

Brittney Lee | Digital

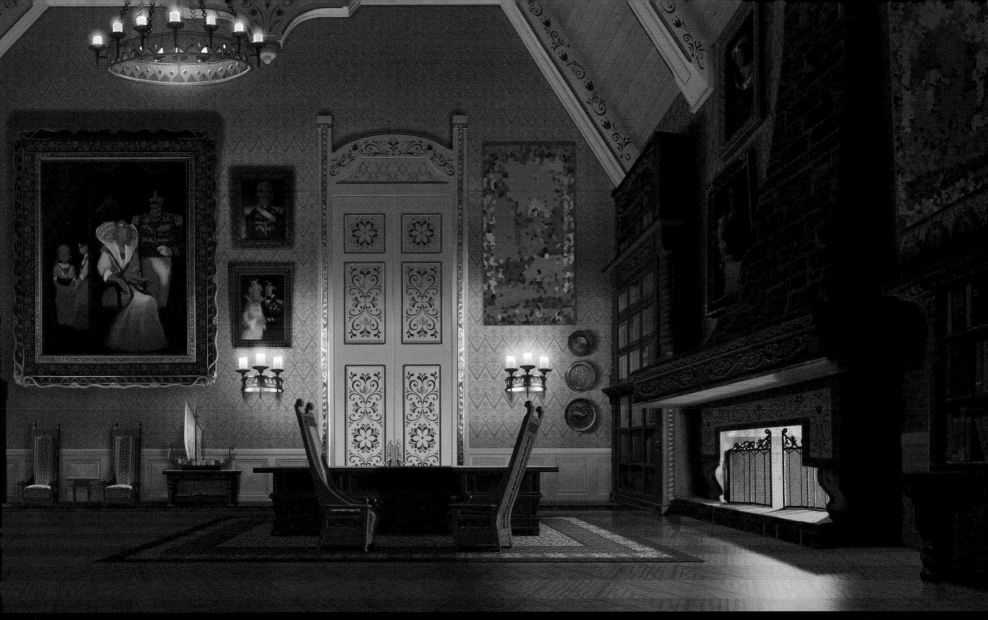

Bill Perkins | Digital

It feels like Mike, David, and Lisa are completely on the same page. They won't always agree, but they always come to a consensus of what's best for the movie. It's really encouraging to go into a meeting with a question and walk out with a clear, defined answer. We don't have time for wishy-washy answers.
—Jon Krummel, environment modeling supervisor

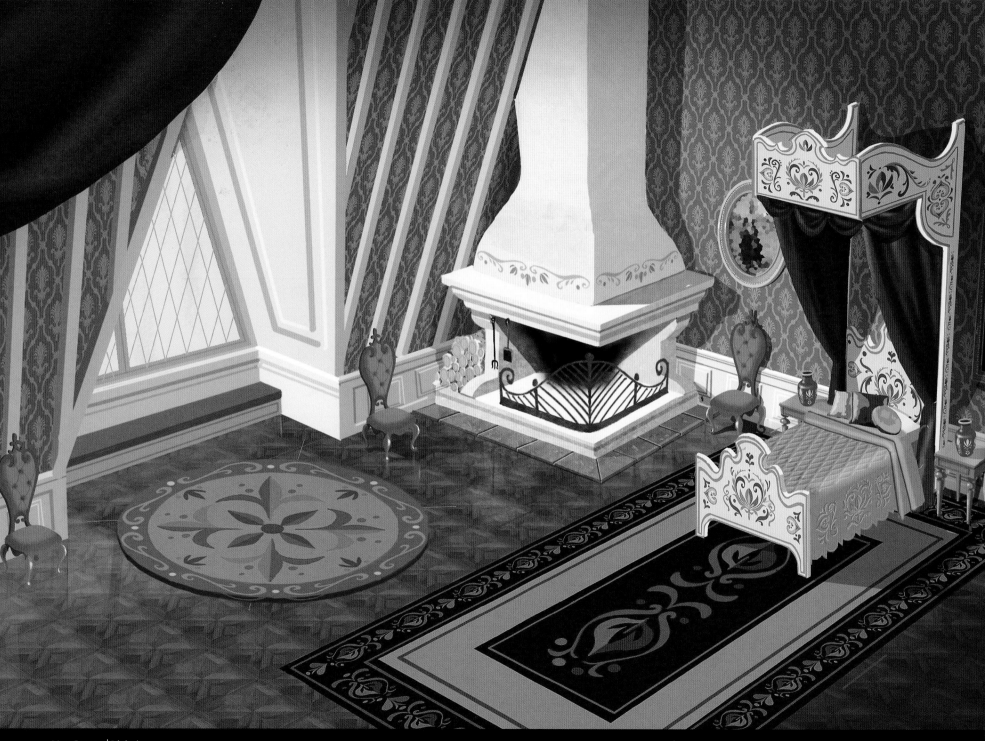

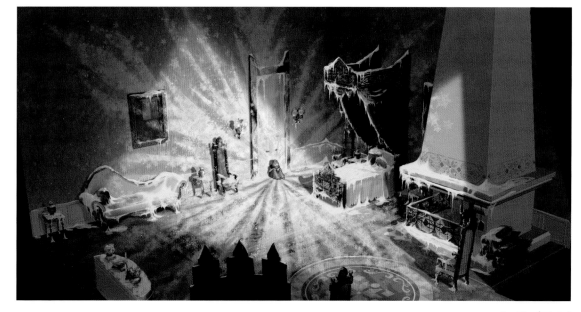

The snow globe Anna is holding was originally a gift from Hans, presented to her post-coronation. The concept was dropped for narrative streamlining.
Victoria Ying | Digital

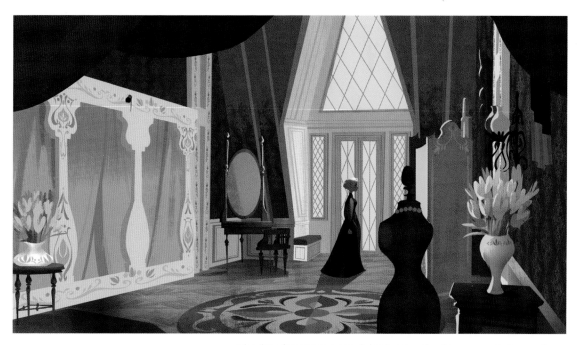

The dressing room was originally conceived as a room between Anna and Elsa's bedrooms. Both sisters were to have shared this room.
Victoria Ying | Digital

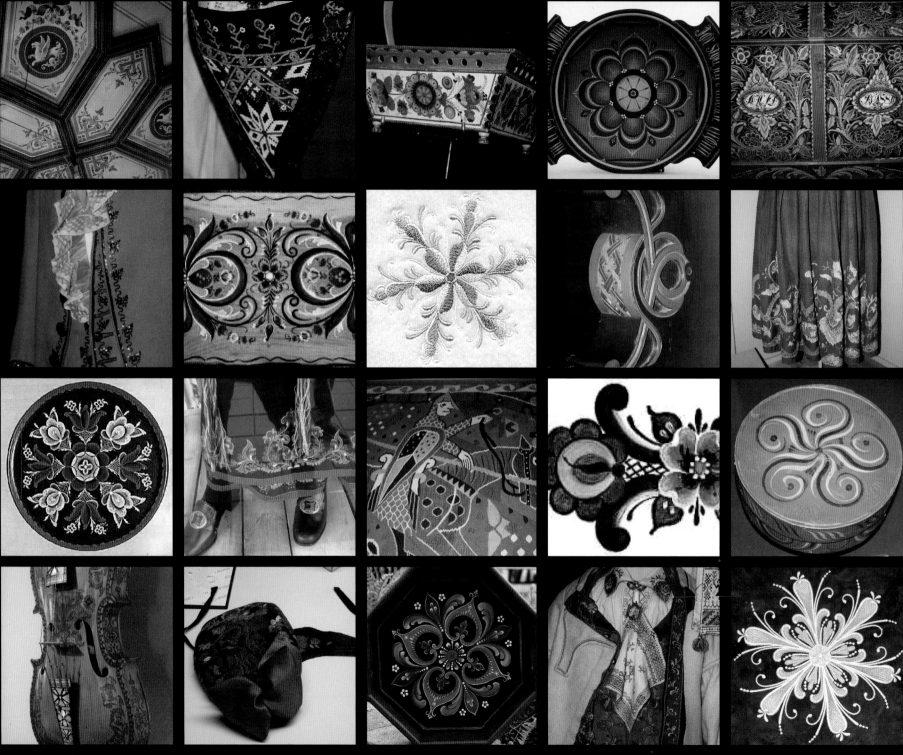

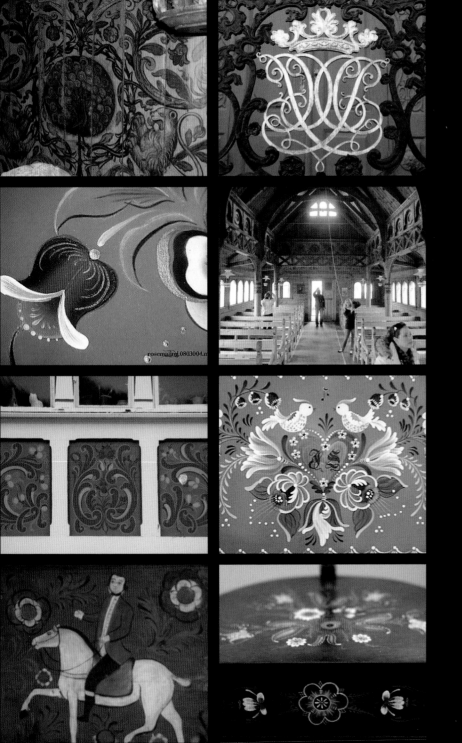

"There was a pre-Norway film and a post-Norway film," says production designer David Womersley. "We were all struck by how much pattern there was. There were textures and shapes that were definitely Norwegian—in the carving, in the furniture, in the buildings, in everything. We want to bring that bold Norwegian patterning into our world, but control it, so it doesn't overwhelm the characters."

"Norway was a bonding experience: I don't think I've ever been on a trip with more loaded into it," agrees Keene. "We needed to find out what was what, what the time period was, what did the costuming look like, how did people live. There's only so much you can get off the Internet. You do your best, but until you get there and see it and talk to people, you don't understand it."

"With our journey to Norway, I discovered a particularly Norwegian look, in folk art, decorative arts, architecture," Giaimo concludes. "It's elegant and extremely organized, and patterned. It's playful but formal. I said, 'We can make it more playful, but it has to be in a very patterned way.'"

One traditional source of patterning is rosemaling (from the Norwegian for "decorative painting"), an intricate style of ornamentation that arose in eastern Norway in the mid-eighteenth century. As it spread and gained popularity as a folk art, local styles and variations proliferated. The Disney artists used it to decorate both costumes and sets.

"Norwegian rosemaling is extremely complex and ornate," says Giaimo. "I realized I'd need to homogenize the hues and make it our own. John Lasseter said he loved the rosemaling concept, but, 'Make sure if you apply it to characters, they don't look like walking doilies.' I took that to heart to create a look that's fresh and lively, but not too dense."

"When you're working with rosemaling, the negative space is just as important as the positive space. All the little decorative stuff can get very congested," cautions Keene. "We have a bedroom with rosemaling on white walls. Because it's colorful and pretty, we have to be careful to keep the values down and the colors harmonizing."

David Womersley, Brittney Lee | Digital

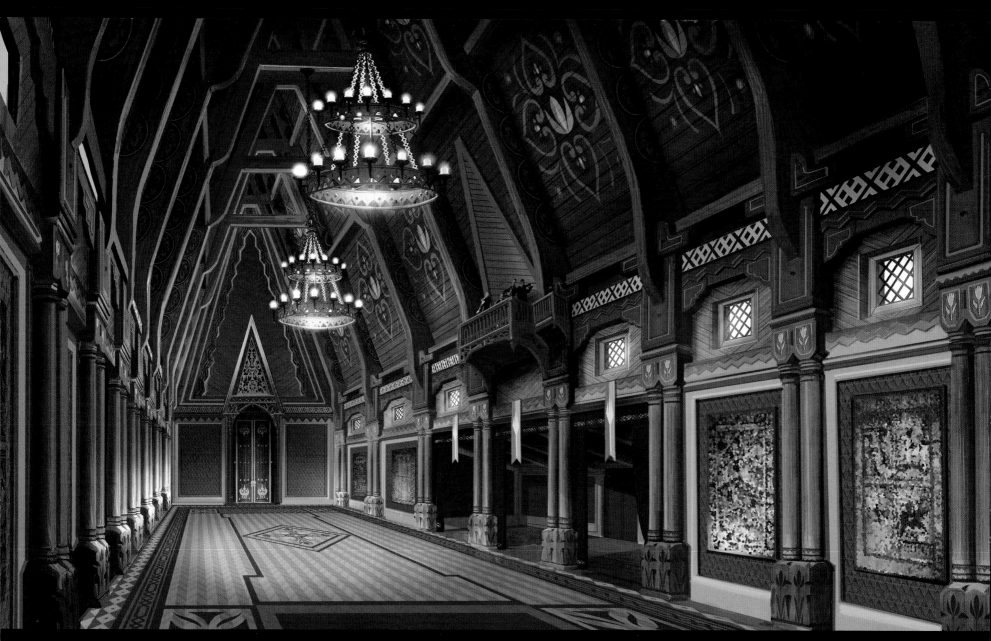

James Finch | Digital

You have to make sure that the wallpaper doesn't come in front of the character. It's a lot of lighting and use of shadow, taking hues back. We'll be dialing all kinds of things, the light, the look, the way in which certain objects are decorated, the textures and patterns. You have so many dials that you can work with to make everything harmonize.
—David Womersley, production designer

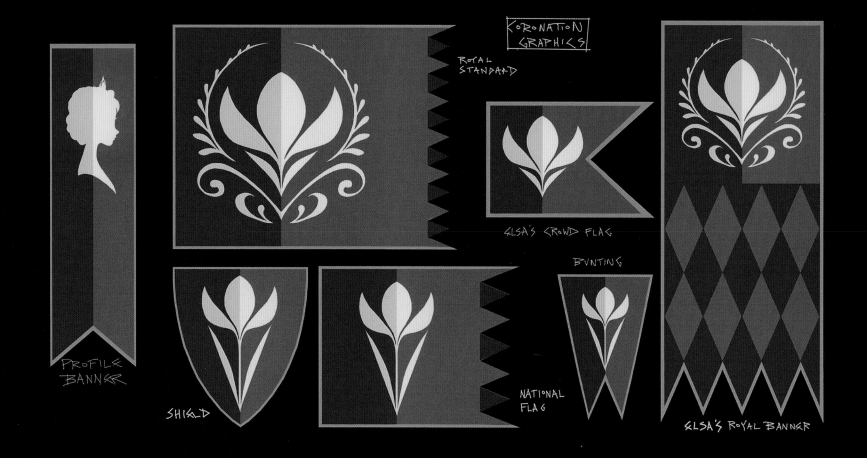

KORONATION GRAPHICS

ROYAL STANDARD

PROFILE BANNER

SHIELD

NATIONAL FLAG

ELSA'S CROWD FLAG

BUNTING

ELSA'S ROYAL BANNER

David Womersley | Digital

Brittney Lee | Digital

Brittney Lee | Digital

Brittney Lee | Digital

Mac George | Digital

Mac George | Digital

The official crest of Arendelle is the crocus, a symbol of rebirth and spring. In colder regions, it bursts forth while snow is still on the ground. The flower appears on everything from banners to capes, uniforms, wallpaper, and jewelry.

Mac George | Digital

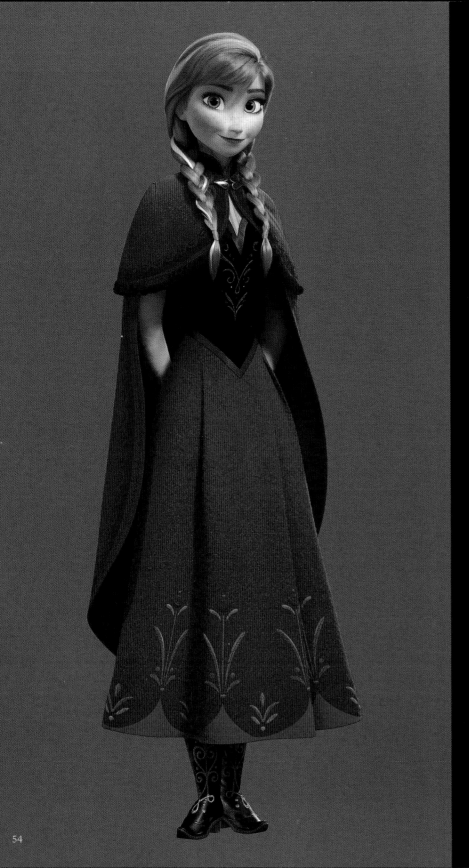

Anna

"Anna's one of those characters that doesn't give up. We all need someone like her in our lives, someone who's willing to stand beside you and make sacrifices for you," explains head of story Paul Briggs. "That's what attracted me to this movie: A character who is willing to stand beside you and stand up for what's right. Her sister was born with a condition that's shaped a world where Anna doesn't belong."

Each of the lead characters presented special challenges and opportunities for the artists. Anna is the emotional heart of the story; she continues a tradition of Disney fairy tale heroines stretching back to Snow White. Story artist Normand Lemay comments, "Usually in movies where someone has a special power, it's your main character. The challenge was to take Anna, the sister who thinks she isn't special or interesting, and make her the center of the story. It was a real challenge compared to *Tangled*, where there the heroine had something supernatural to offer."

"Becky did some of the best Rapunzel animation on *Tangled*," Unten adds. "But what was so cool seeing the test she did of Anna—it was not Rapunzel. She moved in a specific way. Becky found Anna in the quick movements, the quirkiness."

"Chris had a very strong opinion about the shape of Anna's eyes and how best to achieve it," says supervising animator Mark Henn. "That slightly angled almond eye looks great in a drawing, but it sometimes doesn't work right mechanically. You can make cheats easily in a drawing, but in CG, you get that little extra shape over the pupils, and right away the character starts to look cross-eyed. So they have to compensate for it, and then figure out how to get the lids to close in a convincing way. Again, it's much easier to do in a drawing."

Giaimo is an extremely analytical designer, and when he imagined the costumes for the characters, he applied rigorous aesthetic standards. "For Anna's travel outfit, I wanted something that would be really striking and bold, yet elegant," he begins. "She's a princess, and that really blue skirt says royalty, as does the magenta cape. I thought those two colors would be really striking, because there's a rich saturation to both of them. But there's always a little bit of black on the characters: it helps anchor the saturation, so it doesn't float into the atmosphere."

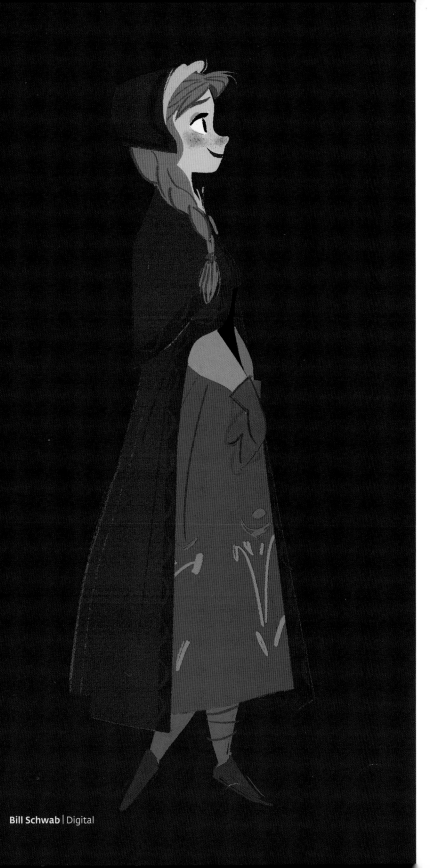

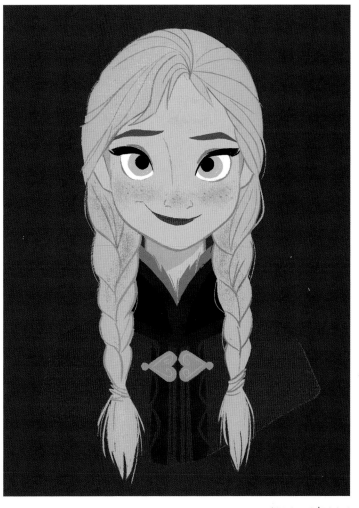

Bill Schwab | Digital

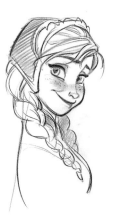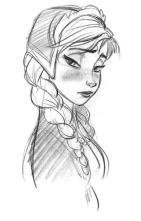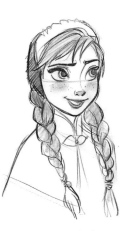

Jin Kim | Pencil

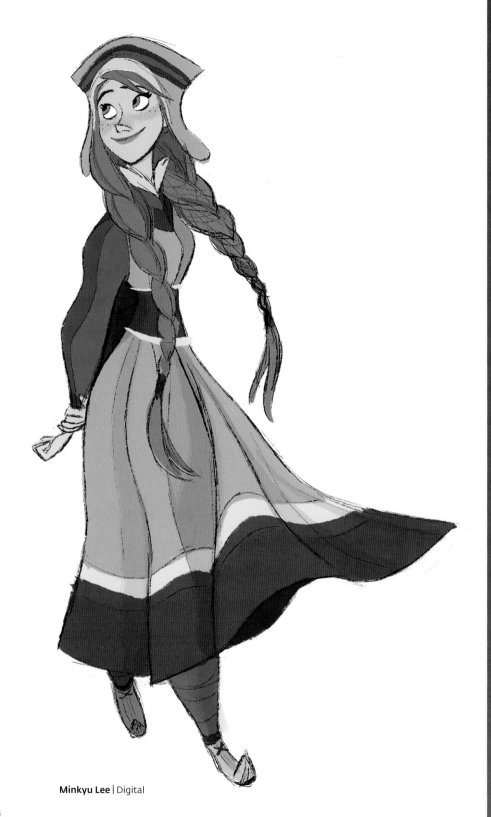

Minkyu Lee | Digital

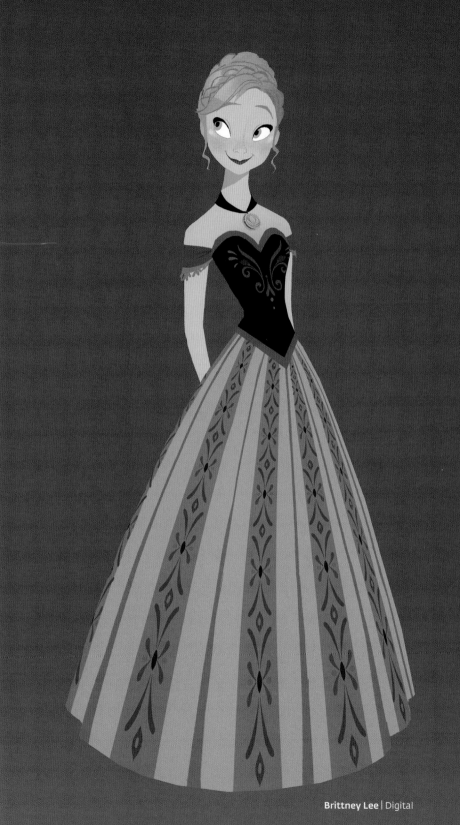

Brittney Lee | Digital

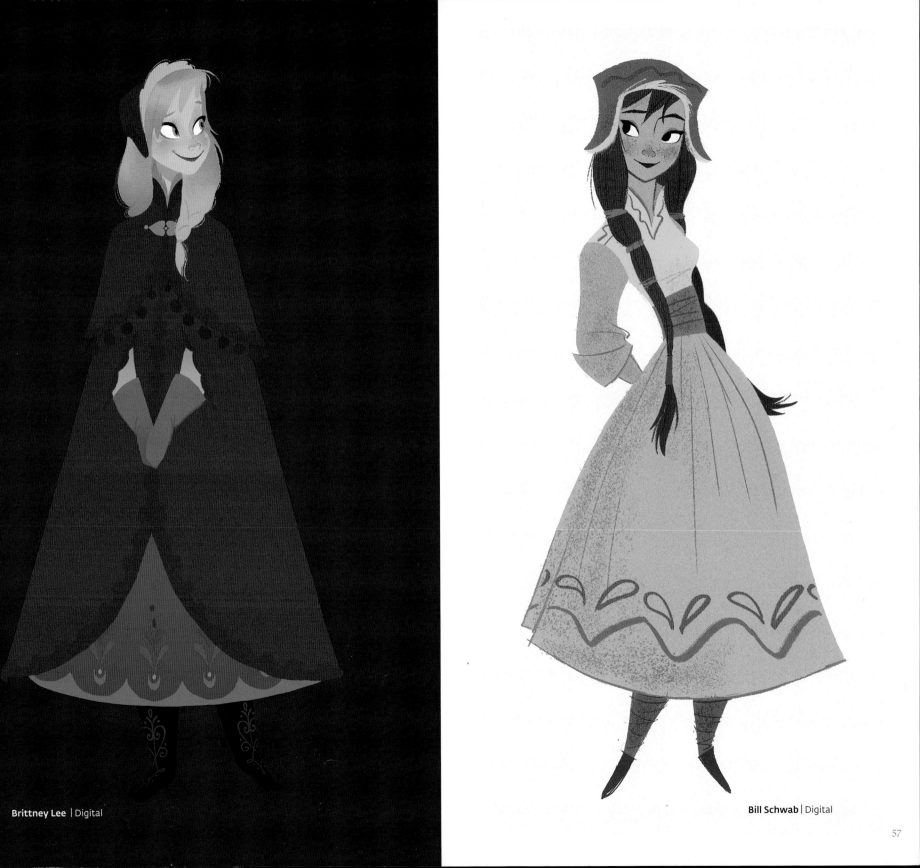

Brittney Lee | Digital

Bill Schwab | Digital

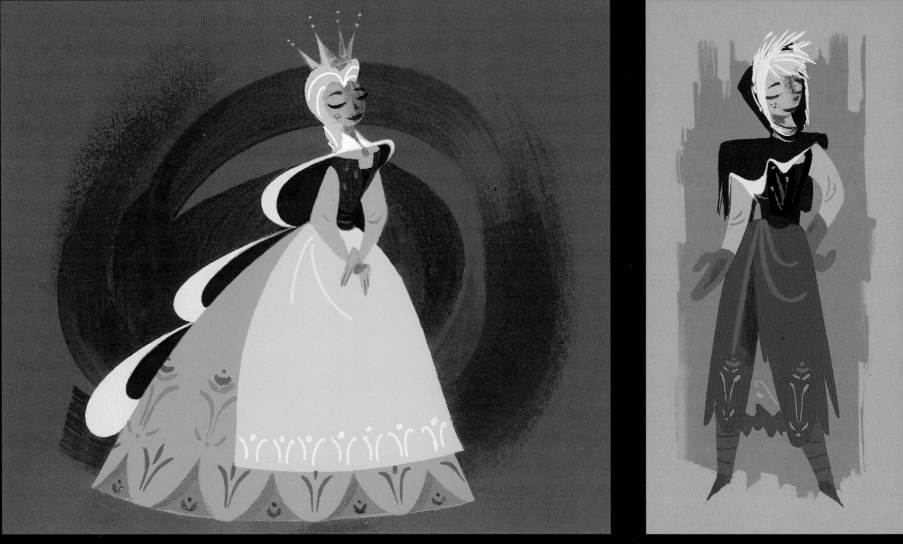

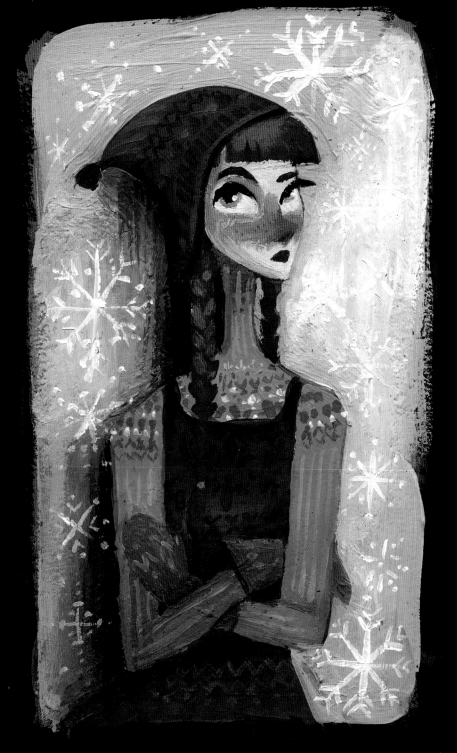

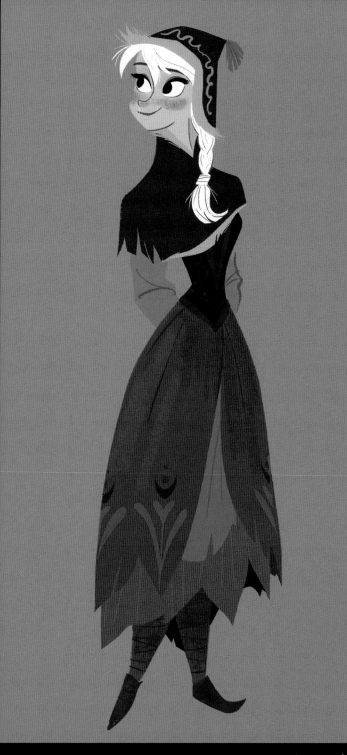

Claire Keane | Gouache

Bill Schwab | Digital

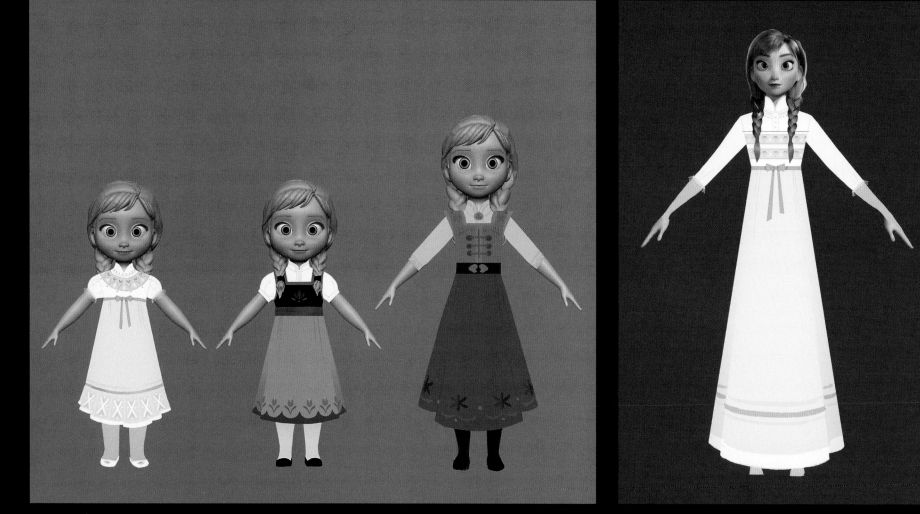

Every outfit you see represents a tremendous amount of work from many artists to construct, tailor, and simulate each piece of clothing.
—Frank Hanner, character CG supervisor

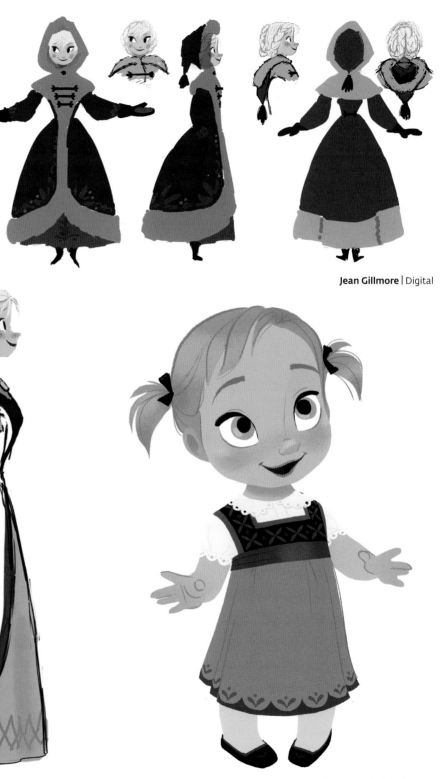

Jean Gillmore | Digital

Jean Gillmore | Digital

Brittney Lee | Digital

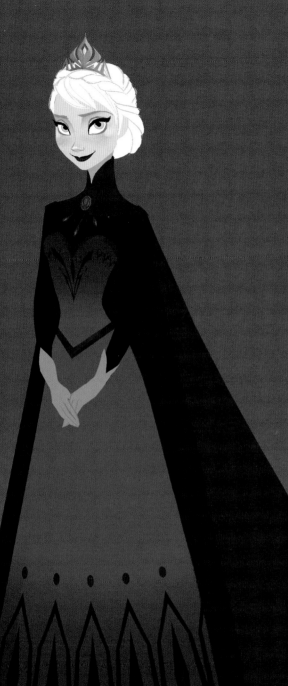

Elsa

Elsa has matured into a beauty whose distant mien heightens her loveliness. Since she was a little girl, Elsa has been groomed for the day she would assume the throne.

In contrast to the open, straightforward Anna, Elsa begins as a repressed character, forced to conceal who she really is.

"Elsa is interesting because she could be perceived as the villain, but she's not," Briggs continues. "We all have something we're hiding. Elsa's afraid, and she needs someone to help her, stand beside her. This a story with two protagonists."

"The fun in Elsa, acting-wise, is you have a character that's been hiding things from her sister and the people in the kingdom," says head of animation Lino Di Salvo. "There's so much fun in the magic, the things she creates, and the freedom she gains. There's so much depth in the characters, and you have emotional connections between them. As an animator, I'm not sure what else you could ask for."

Brittney Lee | Digital

The elaborate costumes on Elsa and Anna were enormous challenges on this film in order to sustain it's appeal. We had dresses that trekked through deep snow, clothing that survived a chase and capes that endured a winter storm. All in the spirit of supporting and embellishing the performances of the two main characters and keeping the believability of how their costumes would react in the various circumstances.
—Mark Empey, technical animation supervisor

Jean Gillmore | Digital

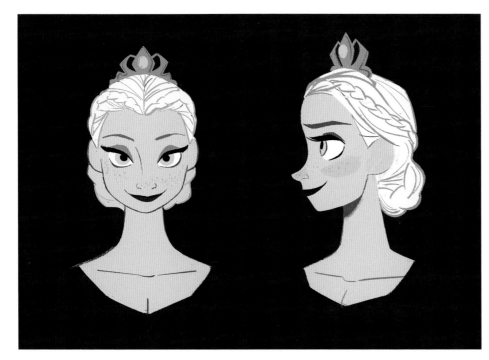

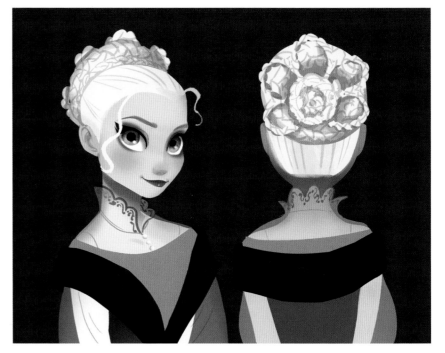

Bill Schwab | Digital

Victoria Ying | Digital

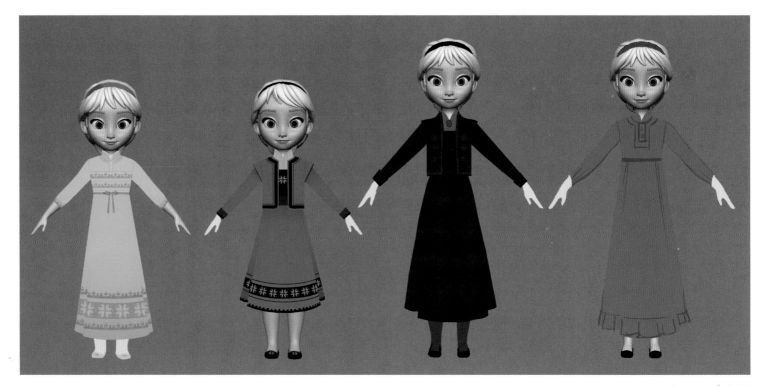

Brittney Lee | Digital

Jean Gillmore | Digital

Early costume designs placed the story in the late 1600s (left). For a more classical fairy tale look, it was decided to place the narrative in the 1840s. The fashions of this time period had a more streamlined and crisper aesthetic than previous eras, which better suited the overall design approach of the film.

Claire Keane | Digital

Hans

Usually, the hero or heroine of a film undergoes a transformation: Aladdin goes from street rat to prince; Cinderella begins as a de facto servant and ends up a princess. In *Frozen*, Hans goes from courtly charmer to power hungry villain.

When he appears during the coronation sequence, Hans embodies courtly charm. His polished looks and manners immediately win Anna's attention. "Hans is this handsome, dashing character: You want the audience to fall in love with him and the relationship he could have with Anna," says supervising animator Hyrum Osmond. "Then we've got to turn him around toward the end and make it a huge surprise. The crew is having fun with the contrasts between the character's two personalities."

"After they screened the film, a lot of the animators said, 'I want to animate Hans,'" Di Salvo chuckles. "He begins as the knight in shining armor, and the audience thinks, 'Anna's going to end up with this guy. He's perfect.' But he's a chameleon who adapts to any environment to make the other characters comfortable. Then you have that awesome emotional turn at the end."

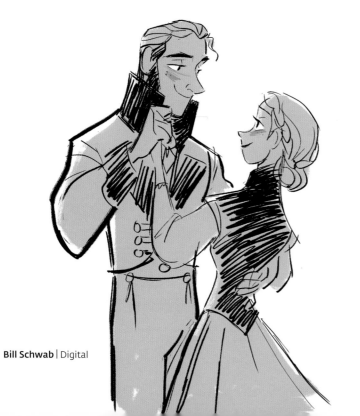

Bill Schwab | Digital

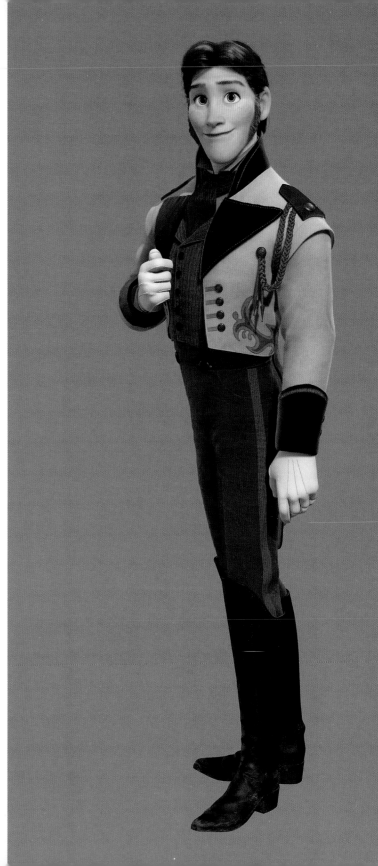

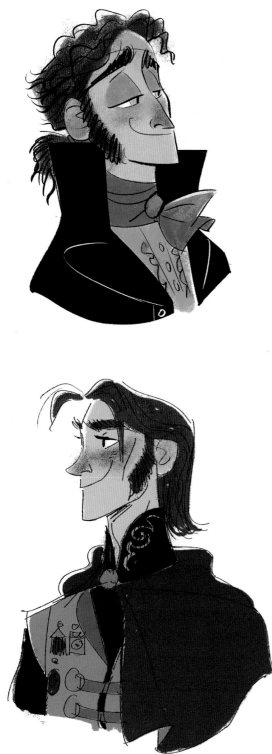

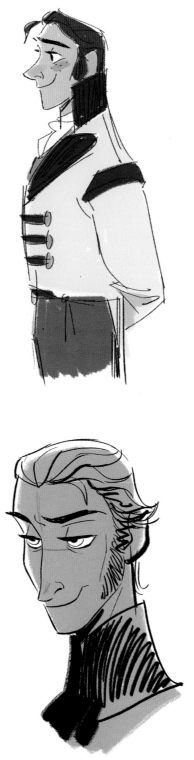

The biggest challenge designing Hans was to make sure we covered all aspects of his personality while never fully tipping our hand to the audience.
—Bill Schwab, character design supervisor

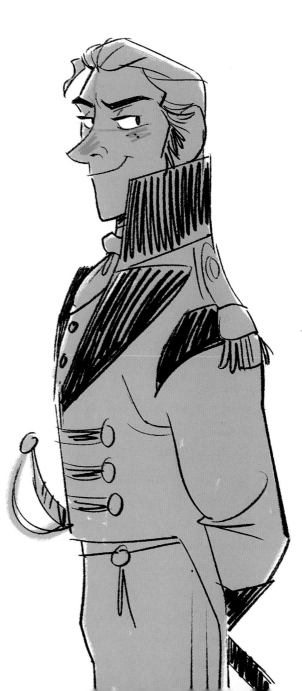

Bill Schwab | Digital

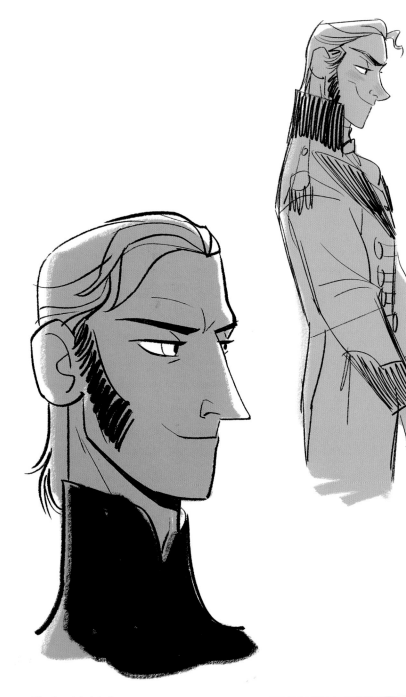

Bill Schwab | Digital

Hans's costume design was inspired by the traditional Norwegian short-waisted male Bunad jacket. The black lapels and collar gives the design a heroic strength. Epaulets and an aiguillette were added to give him a princely bearing.

Bill Schwab | Digital

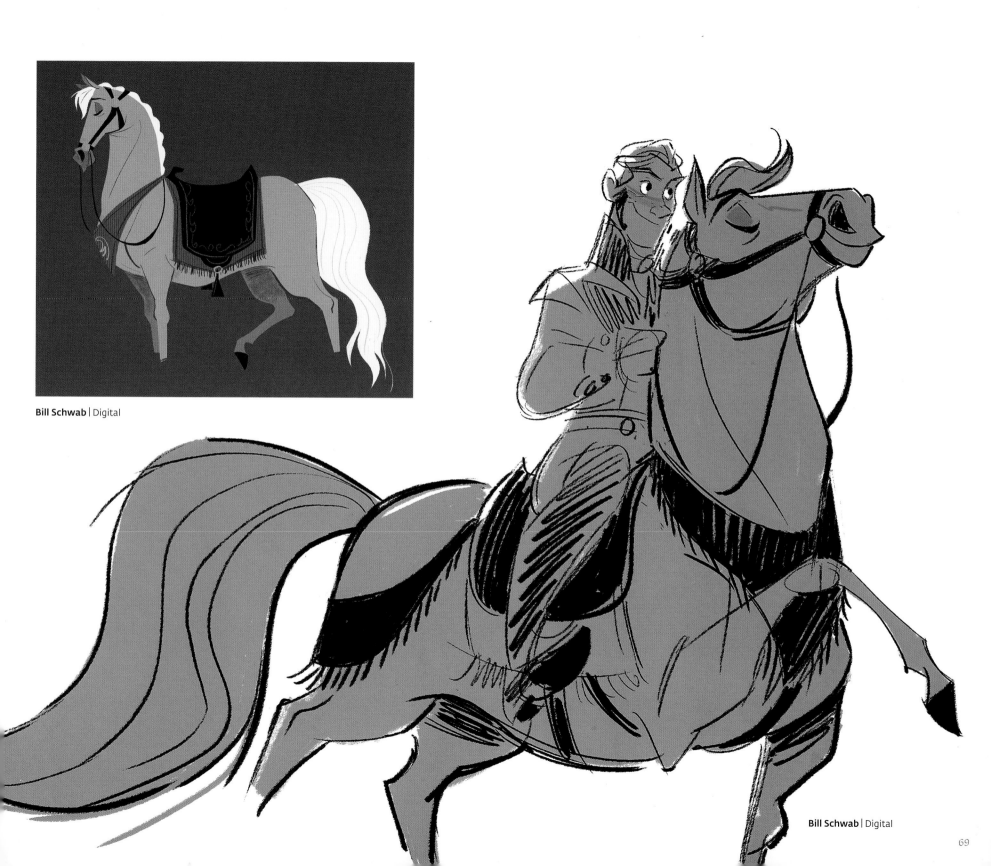

Bill Schwab | Digital

Bill Schwab | Digital

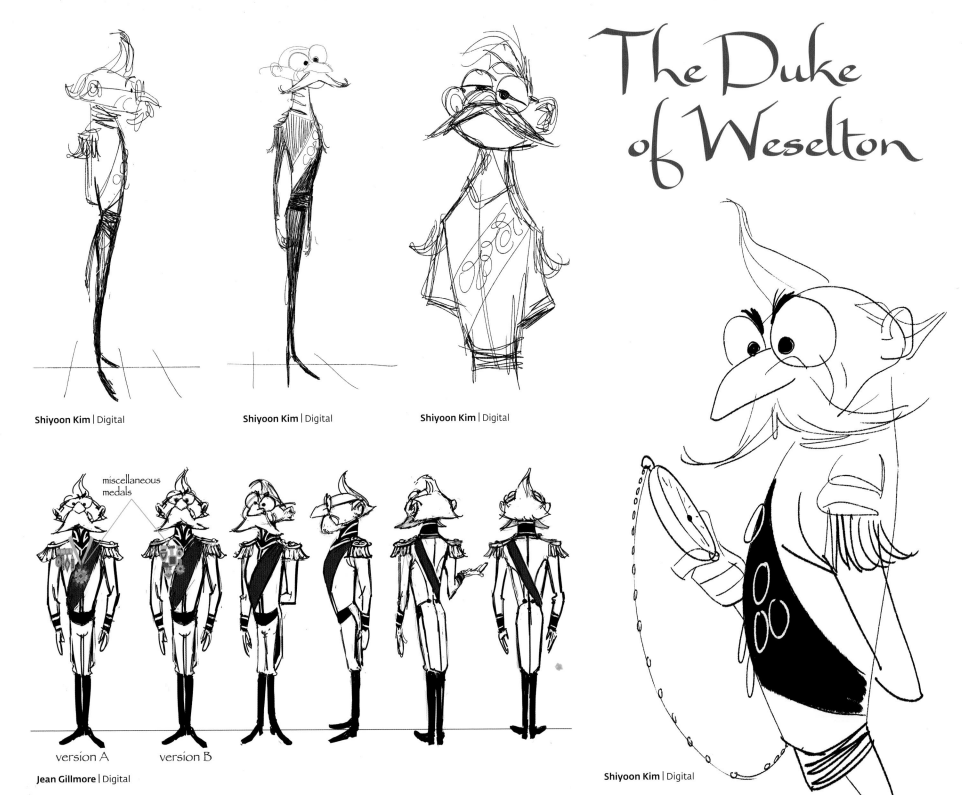

The Duke of Weselton

Shiyoon Kim | Digital

Shiyoon Kim | Digital

Shiyoon Kim | Digital

miscellaneous
medals

version A

version B

Jean Gillmore | Digital

Shiyoon Kim | Digital

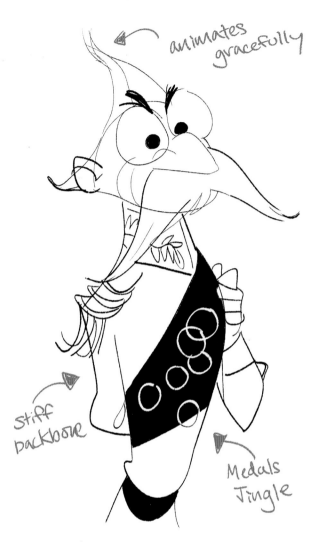

animates gracefully

stiff backbone

Medals Jingle

Shiyoon Kim | Digital

Shiyoon Kim | Digital

The duke's design was originally intended for a benign royal handler to Anna and Elsa after their parents had died. As the story progressed, a design was needed for a villainous character who provided a red herring to the plot line. The old royal handler design proved to be a perfect fit.

I wanted to portray a fussy royal. Thus came the wide thick circular glasses, the extraordinary amount of medals on his chest, the strait "proper" posture of his torso, and his small stature compared to Anna and Elsa who even visually looked dominant over him.
—Shiyoon Kim, visual development artist

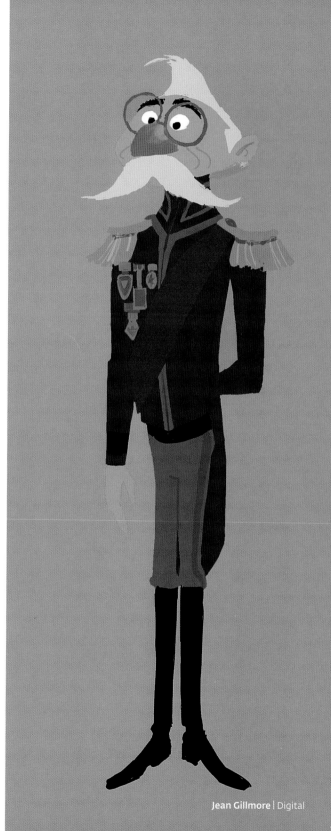

Jean Gillmore | Digital

Costume Design

The patterns on Elsa's cape and the rosemaling on Anna, Hans, and Kirstoff's clothes would be a nightmare in drawn animation. The "pencil mileage" needed for so many details would probably break the budget. And keeping the patterns in register so they didn't seem to crawl over the characters would rival keeping all the spots in place on the cast of *101 Dalmatians*. In CG, it's easy technically, but demands careful planning.

"We looked at a lot of reference that had very complex rosemaling patterns," says visual development artist Victoria Ying. "We had to figure out a way to translate it into a more graphic, cartoony world. It was a difficult translation, because you want to keep all characteristics but still make it feel caricatured and readable."

Development artist Jean Gillmore, who worked on costumes and compares her job to "running a virtual wardrobe department," continues: "They have to be able to construct the outfits in the modeling. Then there's the *simming* (short for simulating, creating believable texture and movement), which is the fabrics: How do they move? What are the actual materials, down to buttons, trim, and stitching? I don't know if this level of detail has ever been done on an animated picture."

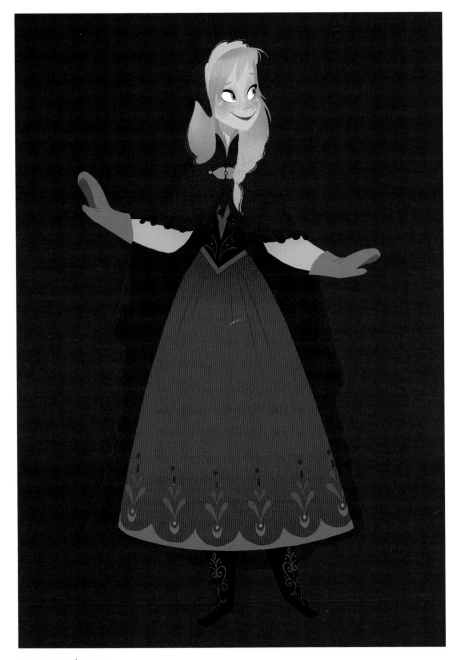

Brittney Lee | Digital

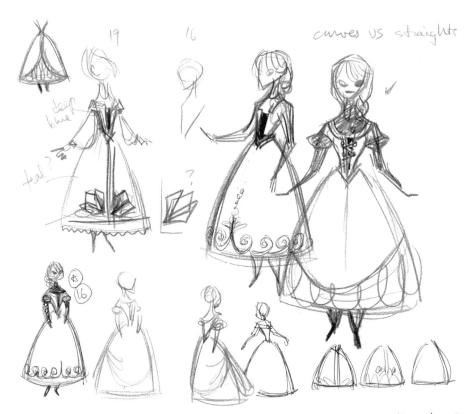

Jean Gillmore | Pencil

"We're bringing out the fine details in the embroidered clothing: if you look closely you can almost see individual stitches," Mohit Kallianpur adds. "We're trying to mimic the properties of different kinds of materials. If it's silk, is it a rougher, raw silk or a shinier, smoother silk? That's going to give us a really rich look."

The artist never lost sight of the fact that the costumes, however intricate, had to support the characters and the story. Ying says, "Whenever Mike Giaimo would do a color pass for us on the costumes, his choices were bold and the shapes were completely readable. No matter how much detail you put on them, it would never overwhelm that basic graphic shape."

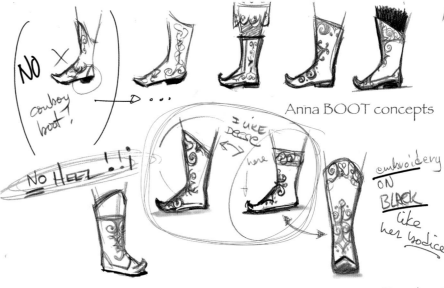

Anna BOOT concepts

Jean Gillmore | Pencil

Anna CAPE applique' STITCH detail

Cape applique SHAPES pattern

***NOTE: applique' stitch is same color as applique' --- here different to be visible!

applique' decorative/securing STITCH

Brittney Lee | Digital

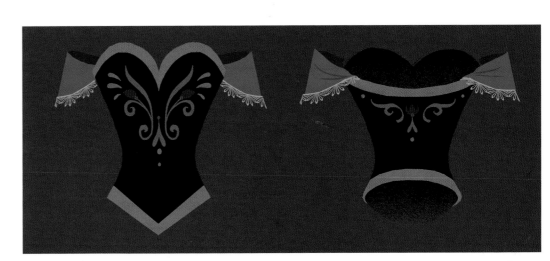

Brittney Lee | Digital

Anna's TRAVELING CLOAK in movement

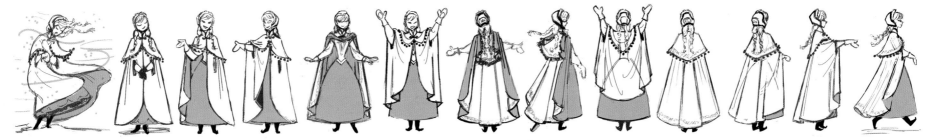

Jean Gillmore | Digital

Michael Giaimo | Acrylic

The color styling of Eyvind Earle (*Sleeping Beauty*, 1959) provided great inspiration for *Frozen*, particulary with the costume palette. Deep, rich, analogous hues and subtle temperature shifts balanced with black helped create a distinctive, shape-based look.

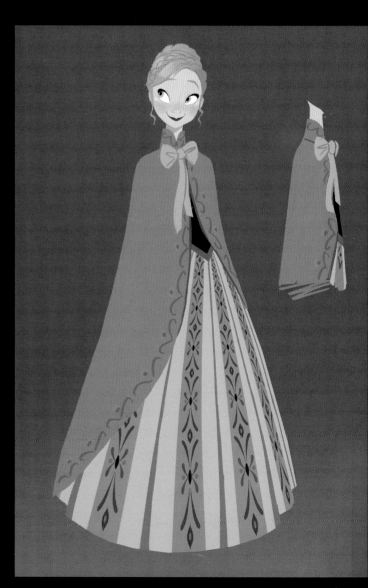

Brittney Lee, Bill Schwab | Digital

In keeping with the traditional Norwegian aesthetic, most of our fabric in *Frozen* is wool. For accents we used velvet, linen, and silk. Since wool is not highly reflective, it provided a great base for saturation. When it came to finessing the details and rosemaling of *Frozen* costumes, Brittney Lee's keen eye and deft touch was essential.
—Michael Giaimo, art director

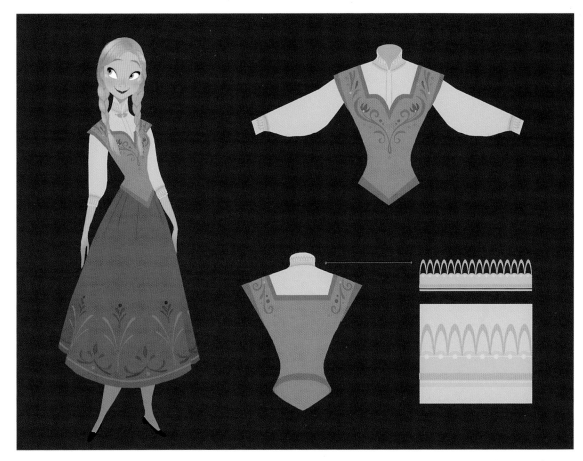

Brittney Lee | Digital

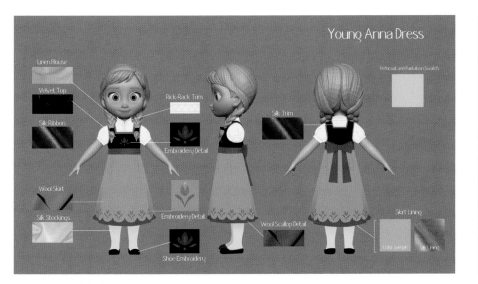

Brittney Lee | Digital

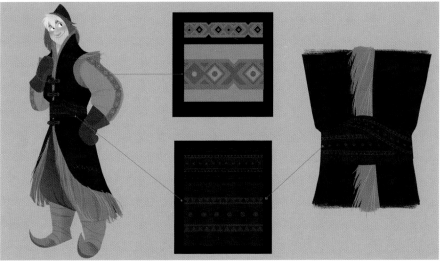

Brittney Lee | Digital

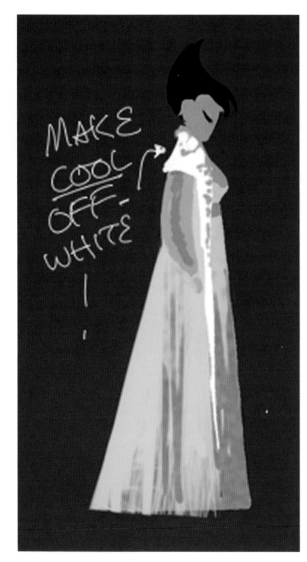

Michael Giaimo, Jean Gillmore | Digital

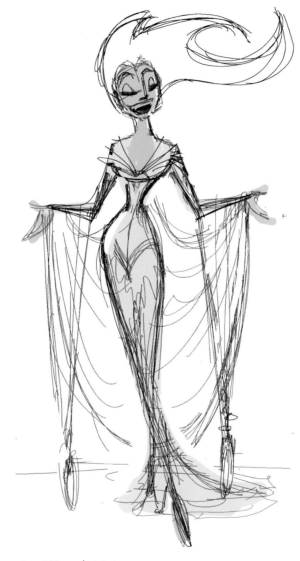

Jean Gillmore | Digital

Jean Gillmore | Digital

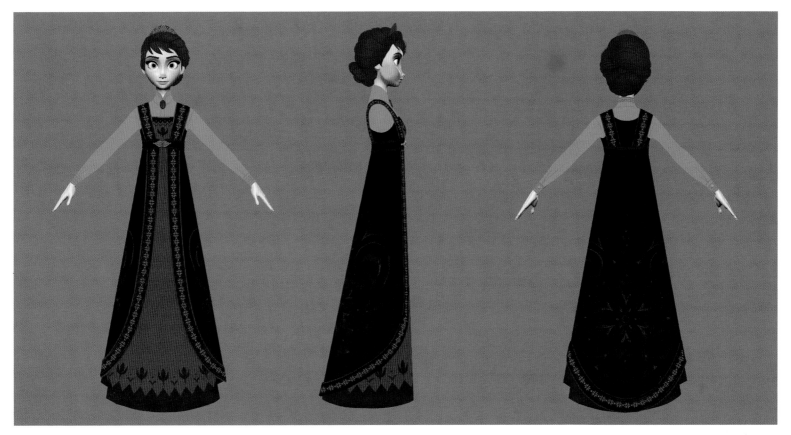

Brittney Lee | Digital

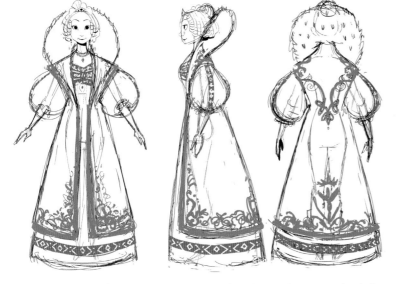

Two things I knew from the start about *Frozen*: It was going to be a costume film and I was going to seek the help of Jean Gillmore to help me realize it to its fullest potential.
—Michael Giaimo, art director

An early version of the Queen's costume design shows a heavy Russian influence. When it was decided to bend the film visually towards the Norwegian aesthetic, the design was streamlined using the Bunad—The traditional Norwegian style of Folkware—as a touchstone for this and all costumes in the film.
Jean Gillmore, Shiyoon Kim | Digital

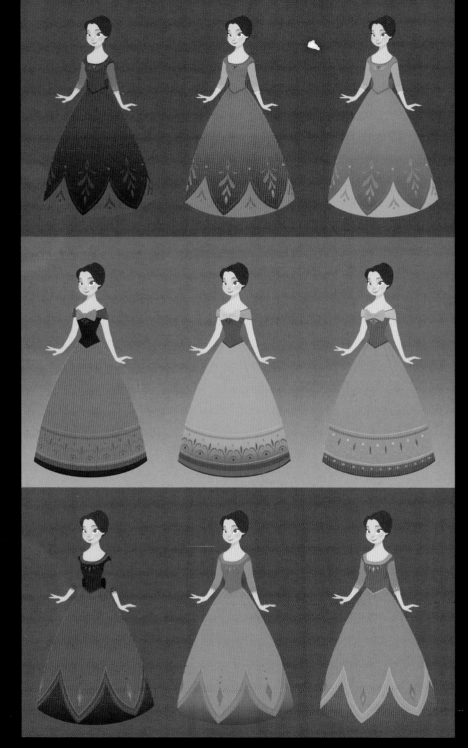

Brittney Lee | Digital

Victoria Ying | Digital

Victoria Ying | Digital

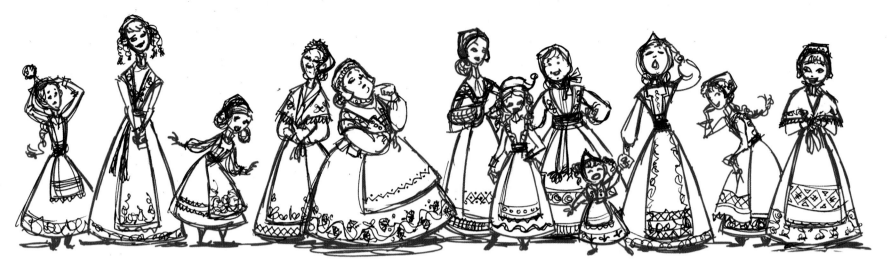

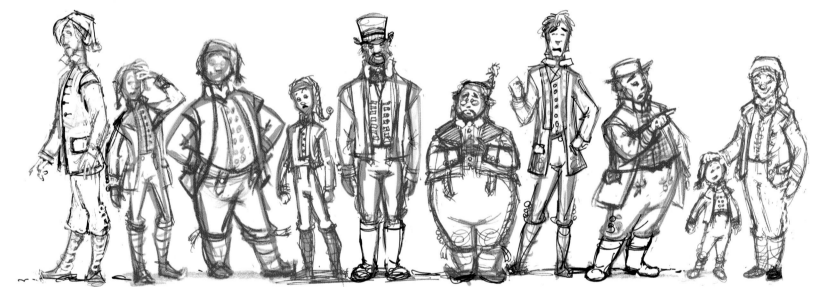

Usually we want to draw the eye to our characters; the rich colors help us. Those same colors help keep the audience from getting confused in crowd scenes. It can be a challenge when we put several colors next to each other; what worked well in isolation now is an issue. But it's nice to have something strong to start off with, and then adjust it as needed.
—Jason MacLeod, lighting supervisor

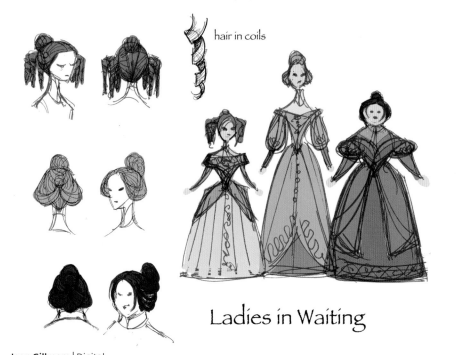

hair in coils

Ladies in Waiting

Jean Gillmore | Digital

Crowds in *Frozen* have been unique, in that color has played such a crucial role, tantamount to form. Using Michael Giaimo's art direction, the crowds helped to further shape and bring more life to the environments.
—Moe El-Ali, crowd lead

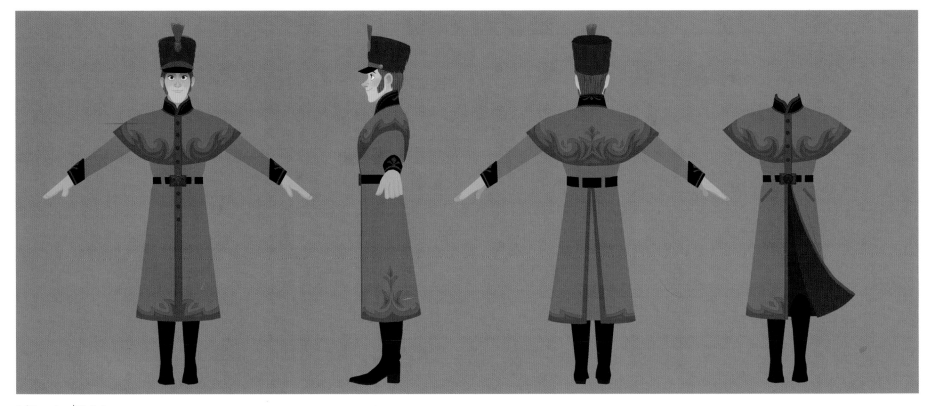

Brittney Lee | Digital

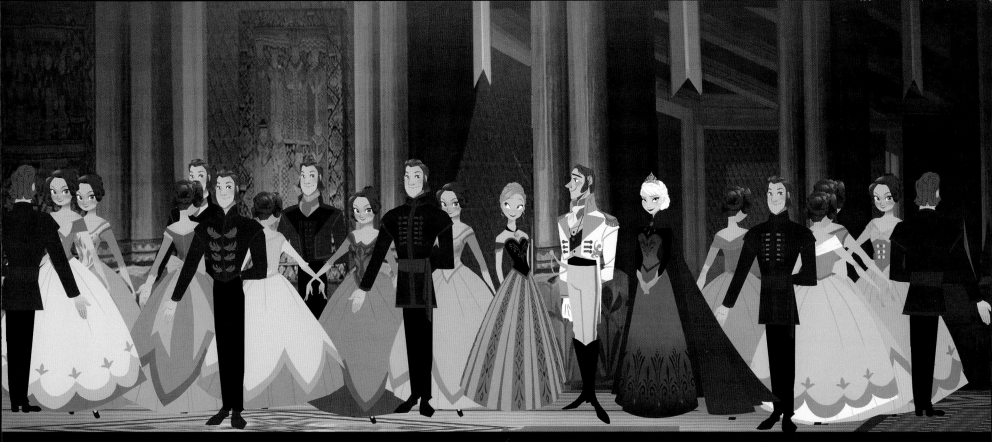

Victoria Ying, Brittney Lee, Bill Schwab | Digital

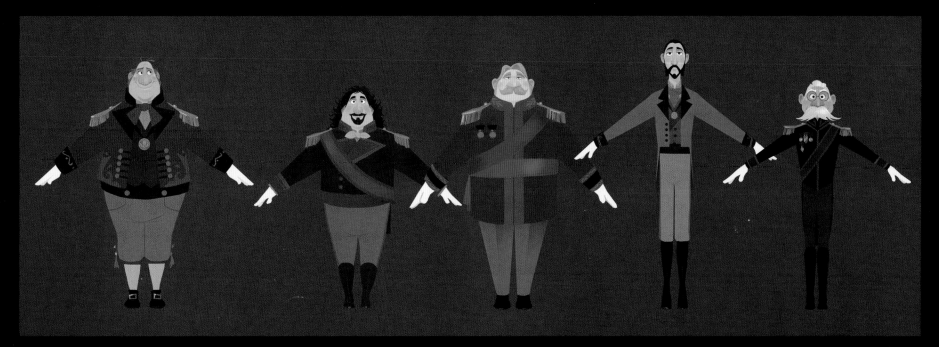

Brittney Lee | Digital

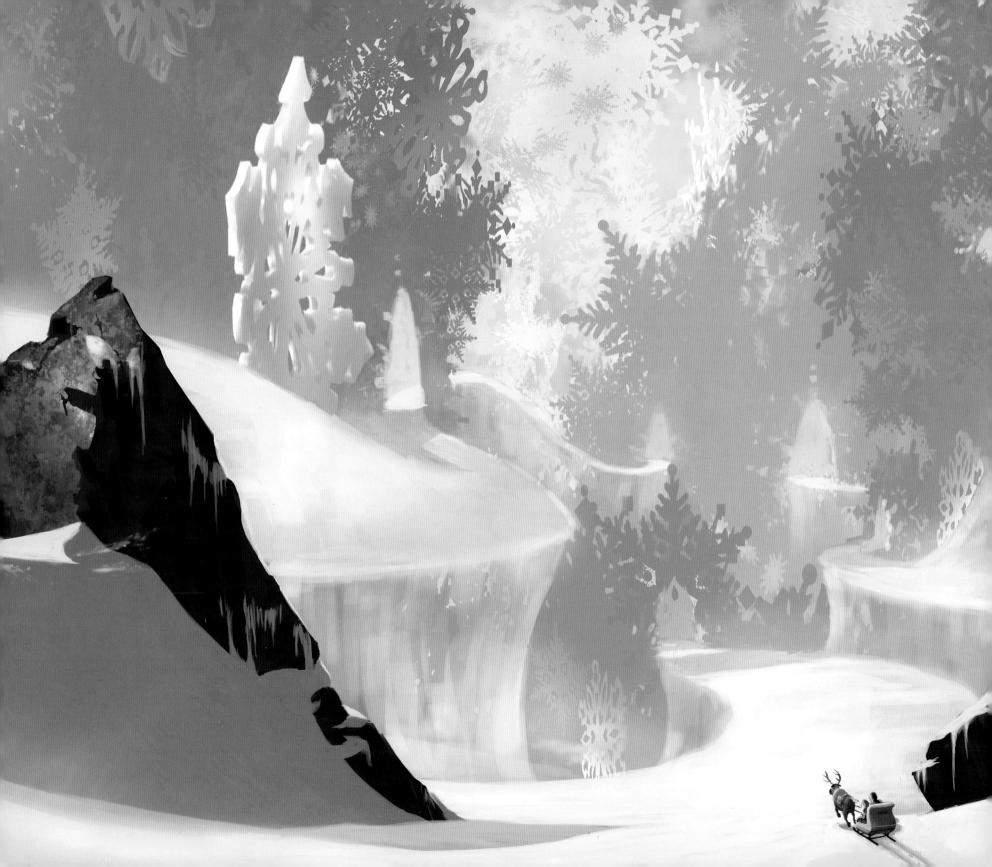

Chapter II

WILDERNESS

Snow became a very powerful design element on this film. Our snow isn't just white—it can be whatever color the narrative demands at any given moment for impact. With this white canvas, we can infuse it with blue, green, magenta or any other hue we choose. I call it the "power of white with light."
—Michael Giaimo, art director

The coronation, which should be a magical moment come true, ends in disaster as Elsa's ability to freeze things is accidentally revealed. She flees into the mountains that loom over Arendelle.

Anna hires Kristoff and Sven to guide her through the snowy mountains to reach Elsa, physically and emotionally. Although Kristoff is a skilled woodsman and ice harvester, the storms Elsa generates defeat even his knowledge of the boreal forests. From the Chinese-influenced thickets that shelter Bambi to the intricately patterned woods in *Sleeping Beauty*, the forests in every Disney film have a unique appearance appropriate to the story. The *Frozen* artists strove to evoke the mountainous wilderness of Norway in scope and detail. Visual development artist Jim Finn observes: "The landscape, the flowers, the color of the water—everything helps you make the setting feel authentic. You don't want to put Lake Michigan water in a fjord."

Jim Finn | Digital

But the *Frozen* crew wasn't making a travelogue. The setting had to be as stylized as the characters; it had to help tell the story. The landscape was buried under a layer of snow that Elsa's magic thickened. But that snow couldn't be just a monotone blanket. As art director Michael Giaimo notes, "Snow isn't just white.

"On our field trip, you'd see deep blue shadows cast in the snow because of the sky," Giaimo continues. "At sunset, there might be orange-reds falling onto that snow. These things are magical and stunning by nature. I don't have to do anything."

Production designer David Womersley adds, "The snow gives you something you wouldn't get anywhere else: a sense of the bleakness of the mood. In some sequences, we want to push the bleakness and the scale. In *Lawrence of Arabia*, the sheer emptiness of the desert gave you a beautiful sense of scale. We have the same opportunity with these huge snowscapes."

That sense of scale enables the artist to make Anna and Kristoff feel as lost physically as they are emotionally. Finn explains, "If you want to make someone feel small or lonely, you put them in a large space. You can use all that snow to make them feel alone in a very desolate place. You're going to have big mountains, big skies, and a lot of space. There are going to be moments in the film where we want the characters to feel they're on their own. There's no castle in the distance. If you see nothing on the horizon, it's scary."

Every tree, rock and snow bank in the forest had to be designed to fit into the highly stylized world of the film. "Mike and David wanted this film to feel design-y, a little more thought out," Finn says. "It's fun to do, but it's more work to design shapes, as opposed to just filling in the space around a character. It's building a stage for the characters. You place a tree so that it works as a negative in a big positive shape. You're designing for shape, because you have such a large area of white—it involves a little more thinking and not just painting something in every corner of the image."

Fairy tales are often environmentally intimate.
It is a very rare opportunity to imbue the genre
with the kind of scope and scale that *Frozen* has.
—Michael Giaimo, art director

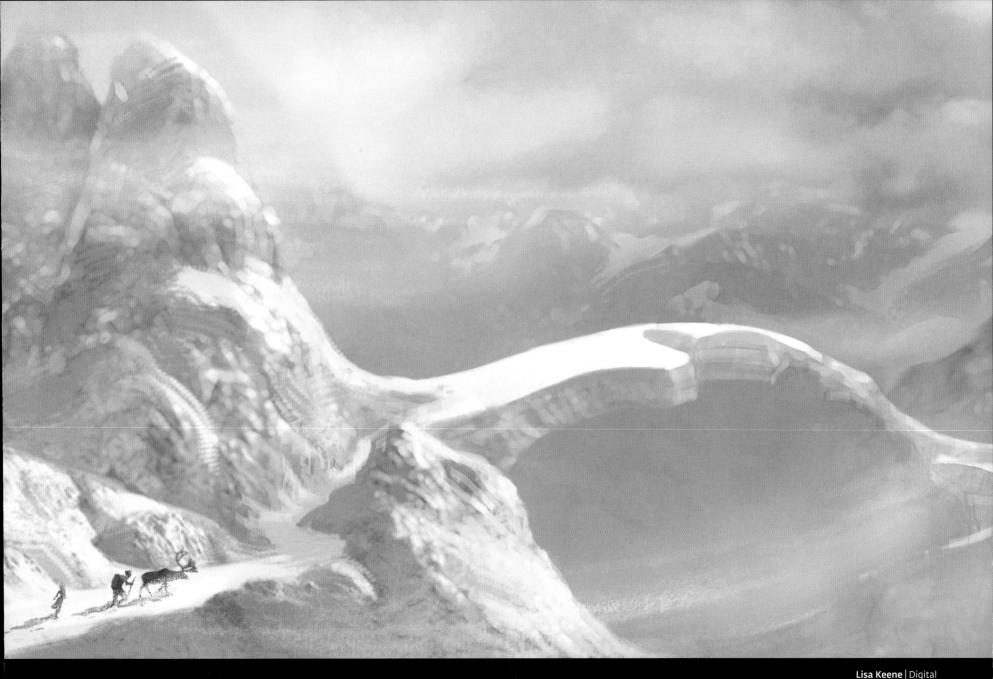

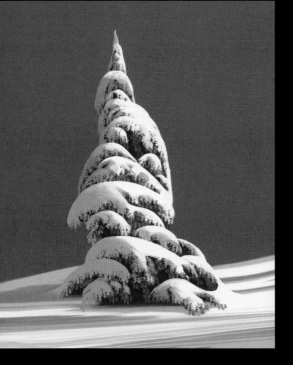

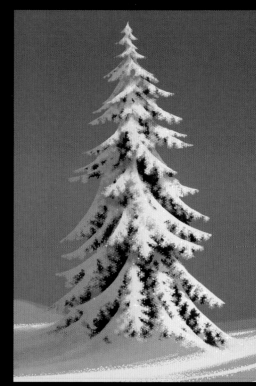

We had a broad variety of trees. Some were more natural and some were very stylized like the trees in the magical landscape. Besides the challenge to make the look believable they had to integrated well with the environments and still be renderable.
—Hans-Jorg Keim, look development supervisor

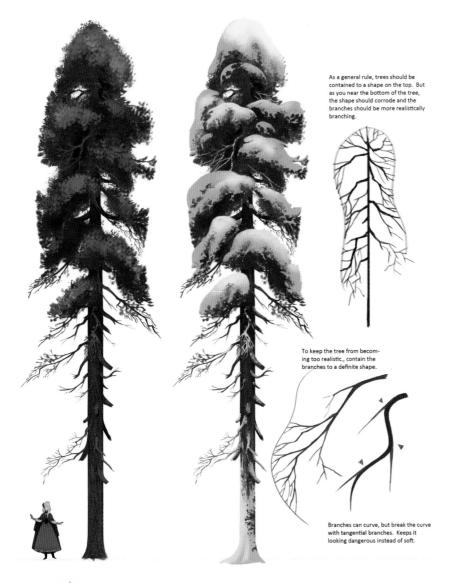

As a general rule, trees should be contained to a shape on the top. But as you near the bottom of the tree, the shape should corrode and the branches should be more realistically branching.

To keep the tree from becoming too realistic., contain the branches to a definite shape.

Branches can curve, but break the curve with tangential branches. Keeps it looking dangerous instead of soft.

Cory Loftis | Digital

Lisa Keene | Digital

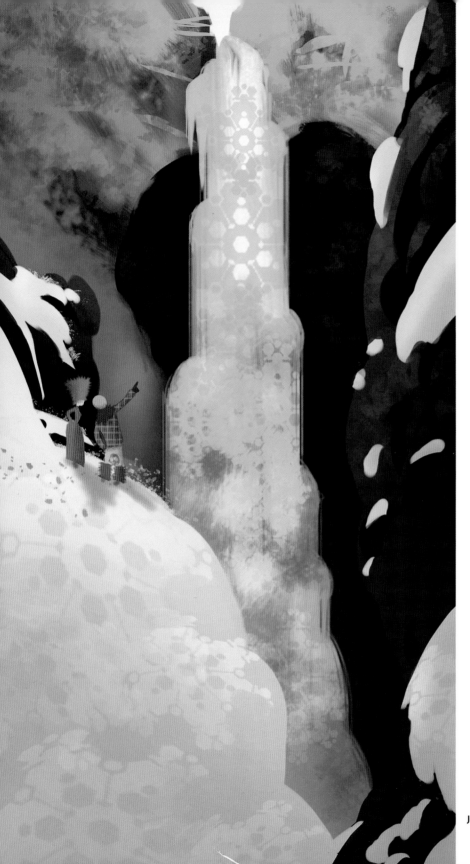

Environment modeling supervisor Jon Krummel, agrees ruefully, "This film has technical challenges, and it has artistic challenges: Everything needs to be art directed and sculpted. It's going to add a lot of geometry and a lot of density to every single set, which doubles the work. They're writing a tool called Banzai for us that will procedurally create any kind of tree; if we need a certain kind of branch, they'll write a module for us to make that happen. I'm really excited to play with it."

The demands of creating such a complex environment led various crews to work more closely. Character rigging supervisor Carlos Cabrol notes, "The effects department provided us with a snow representation: when the characters walk through it, they leave footprints. We're also enabling the animators to send their animation off to get rendered. The animation will come back with the hair, fur, cloth, and snow rendered, so they can judge how their work is interacting with the environment."

Effects supervisor Dale Mayeda adds, "We've had one of our effects animators, Ian Coony, live up in the layout department. When a shot is conceived, we put in a representation of the effects. The animators get a rough idea of how much snow might be in the scene; they can respond to the weather conditions. Typically we're not involved until after the animation's completed. They may not know there's a really gusty wind blowing, and their characters may not act appropriately. By having our guy up there, they've gotten a better understanding of what's happening in the shot."

Bill Schwab | Digital

Justin Cram | Digital

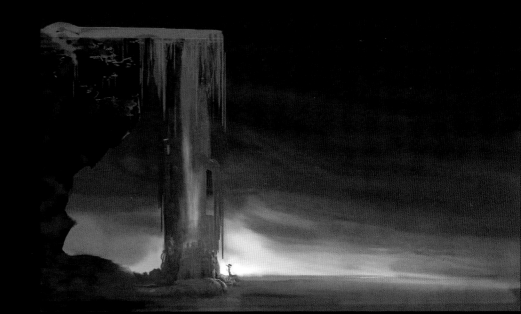

Snow is an opportunity, because it's a white canvas. It's a lighter's dream, in that the lighting is the color. The local color is minimal at best in all these snowscapes, so it's all about the lighting. We consider it a blank canvas that allows us to actually paint with light. We're having a lot of fun with that.
—Lisa Keene, assistant art director

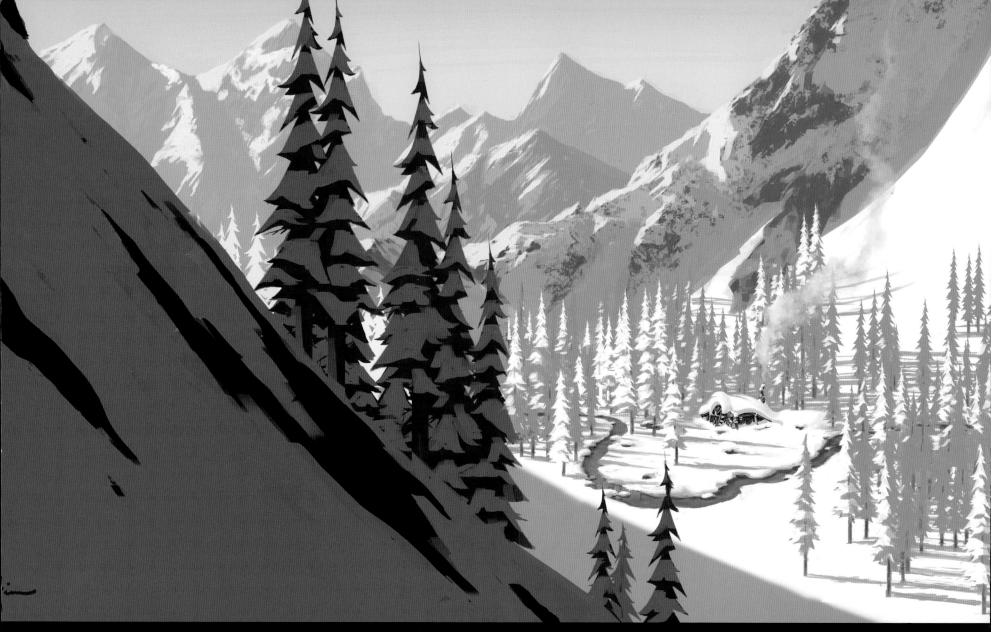

Jim Finn | Digital

All our locations are designed with the textures, patterns, and the look of the actual location.

Bill Schwab | Digital

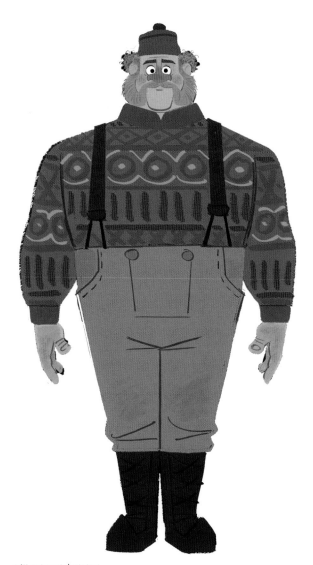

Bill Schwab | Digital

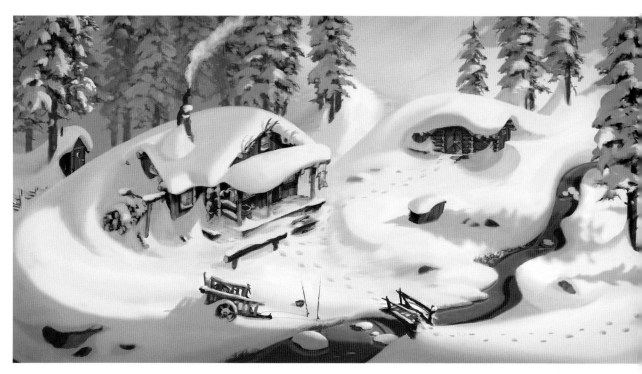

Jim Finn | Digital

Jim Finn | Digital

us. We haven't done this amount before in a movie, and making it look believable is not easy: it can easily go from snow to concrete. The subsurface techniques we're developing will give us a feeling of light hitting the snow and traveling through it. As light travels deeper into snow, the red wavelengths get absorbed, so it gets bluer. We want to capture those phenomena."

Finn notes, "Depending on the time of year, the sun only goes so high in the sky. We want to make it seem like winter, so the sun will probably lay pretty low on the horizon. Whatever the story and emotion require, we'll do, even if we have to cheat."

In earth science classes, students learn about *albedo*, the amount of sunlight snow reflects; skiers and snowboarders know about it firsthand. Kallianpur continues, "We don't want audiences to have to wear sunglasses because of how much snow we have in a frame. But if snow doesn't have a certain level of brightness, it starts going gray and looking dirty. All of our snow is going to be beautiful and clean."

"During the day, snow can be very high contrast, but we have to give the audience time to rest their eyes," concludes lighting supervisor Jason MacLeod. "We have night scenes; we have interiors. On *Bolt*, we had one white dog and the background lit pretty well. We have the opposite problem: The entire stage will be white to some degree. It'll be a lot of work to keep the audience interested in the characters and not overwhelmed by the backgrounds."

It would be a crime not to celebrate color in the musical format. Since John Lasseter appreciates my color and design sensibilities, he expects me to deliver something in a striking and provocative way.
—Michael Giaimo, art director

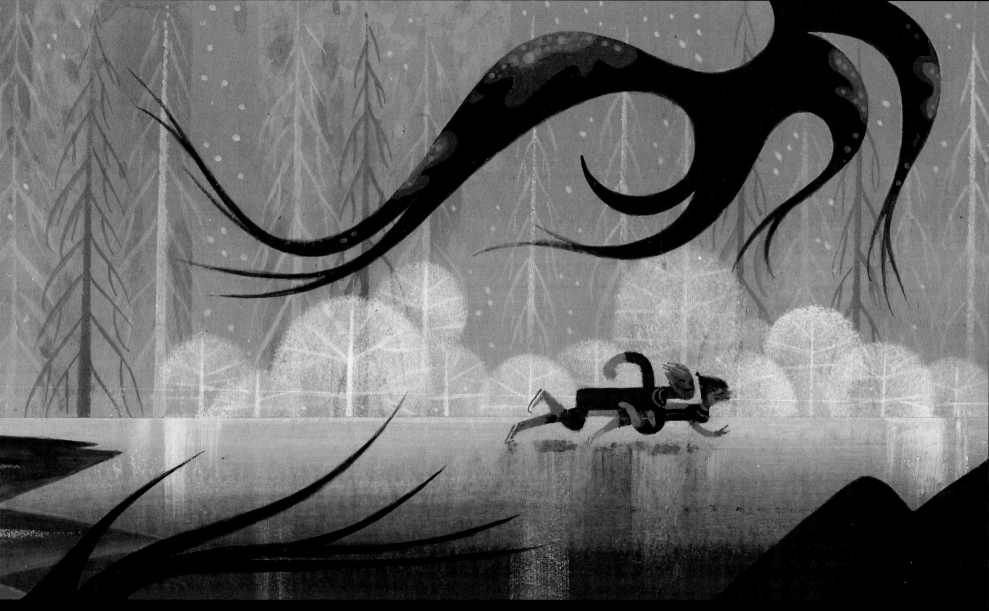

Strong color and shape orientation was essential for building the design language for *Frozen*.
Michael Giaimo | Acrylic

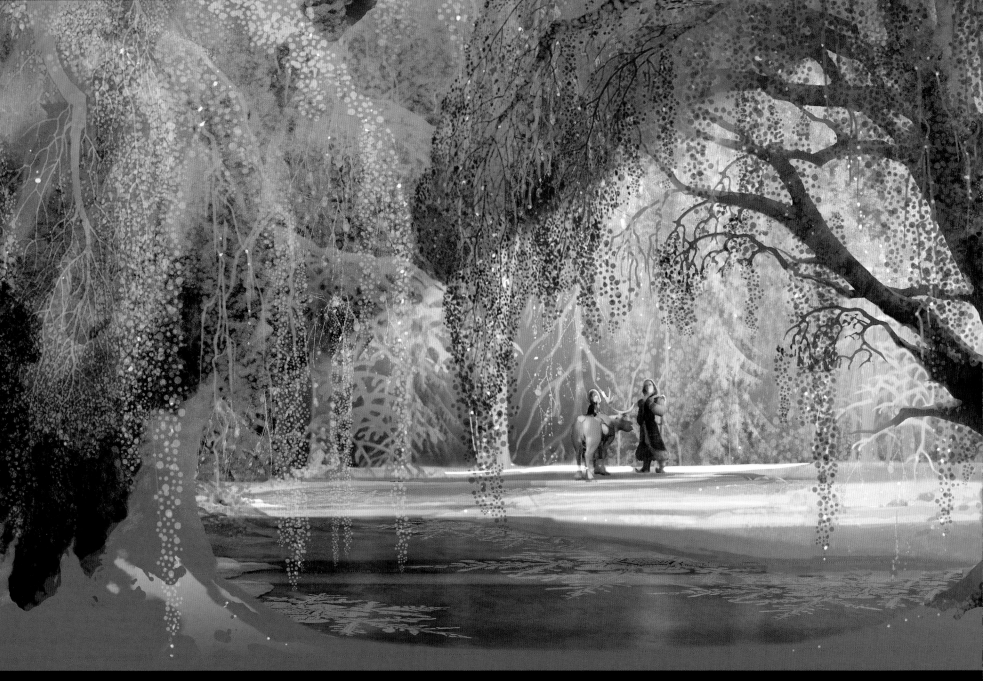

The fully realized world of *Frozen* required a blending of graphic design conceits, combined with the very real properties of light, shadow, texture, and form.
Lisa Keene | Digital

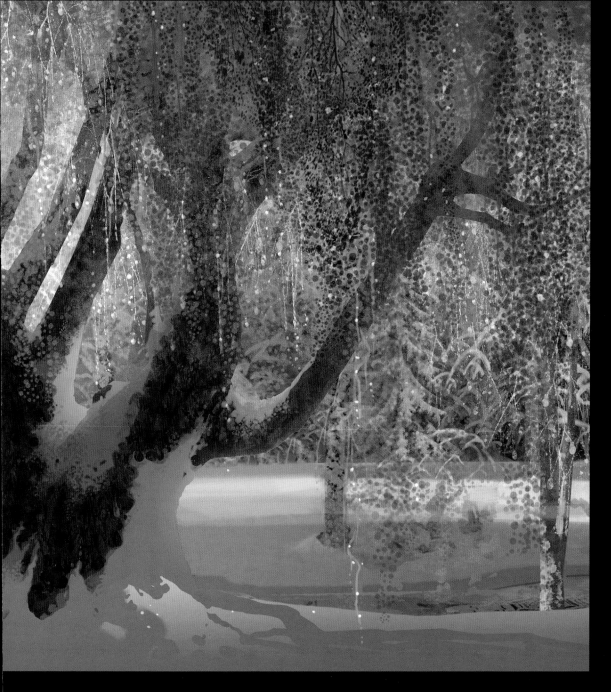

The scope of the landscape is enormous. There are entire mountain ranges. Lewis Siegel had the idea to build a "Frost Modifier," which has been really useful not only for LookDev but also for EFX. With this new technology we were able to frost the entire world and encase everything in ice.

—Hans-Jorg Keim, look development supervisor

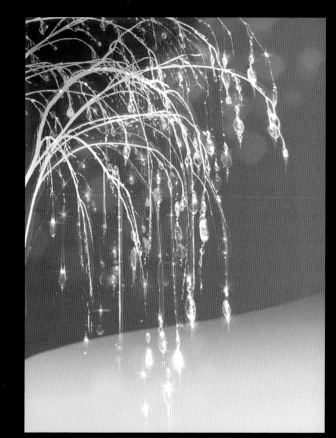

Lisa Keene | Digital

COLOR KEYS

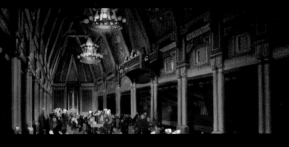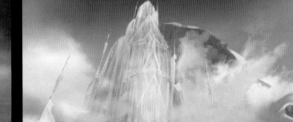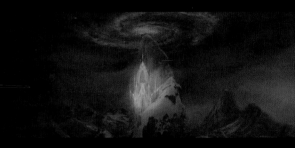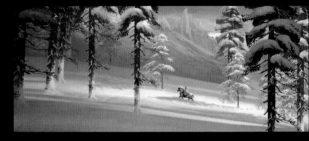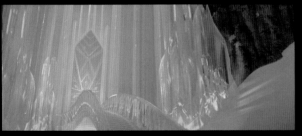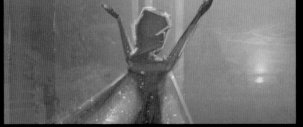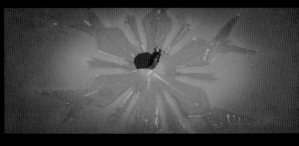

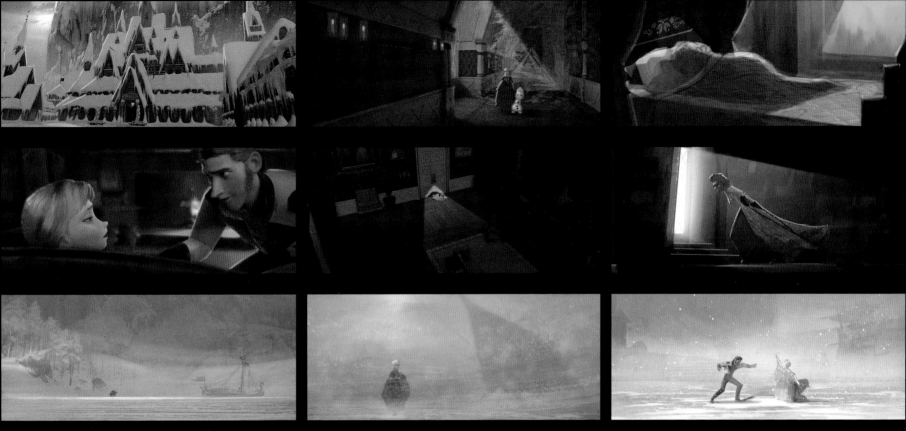

Lisa Keene has the ability to blend her deep understanding of the physical laws of nature with the more elusive qualities of the fairy tale world. Her color keys in *Frozen* provided a solid framework for our lighting department. The keys are both grounding and transporting— exactly what is needed for an elegant Disney fairy tale.
—Michael Giaimo, art director

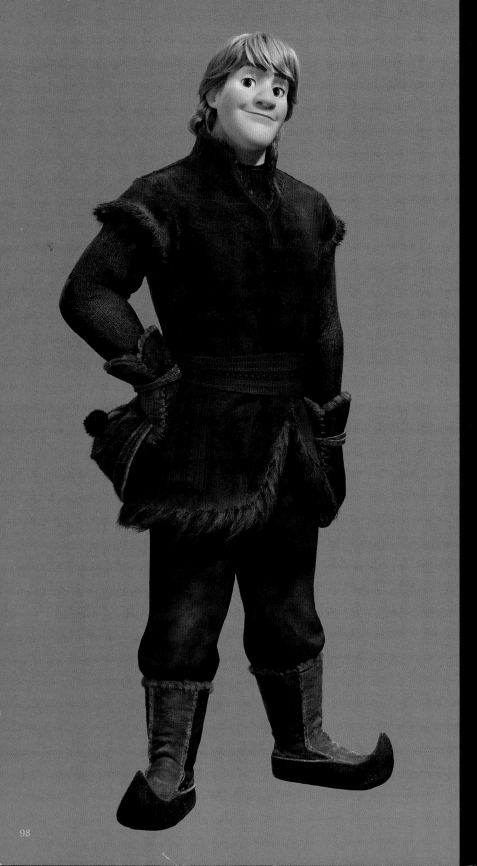

Kristoff

For decades, the princes were the most difficult and least interesting characters in animated fairy tales. *Frozen* has a partner for Anna; he's not a prince and he's often less than charming, but he is a hero.

Unlike the blandly elegant princes in many animated fairy tales, Kristoff is tall, powerful, and scruffy. An outdoorsman and a loner, he's a man of few words and fewer friends, except for Sven, his reindeer/pack animal/best bud.

"Kristoff's a tough, quiet, rugged ice harvester. He doesn't relate to humans as much as he does animals," says animator Tony Smeed. "It's fun to portray his emotions and thought process without being too wordy. He's a man of few words. He'll probably be more efficient in his movements, using just enough strength to get the job done. Underplayed."

"Kristoff represents that code of being a *man*, being very tough, but there's a softer inner core," adds head of story Paul Briggs. "He built this mask and he's worn it for so long, he almost believes in it. Like Elsa, he's hiding something. Anna is going to push him to lower that mask. We had to know who Anna was before we could to figure out who we needed Kristoff to be."

Kristoff's rough-hewn appearance had to contrast with the courtly elegance of Anna and Hans, yet fit into the same visual realm. "Kristoff was tough to get in line with the other characters, because I was channeling live action musicals, which have a real panache; how do we bring that to this rustic character?" Giaimo says reflectively. "We riffed on the traditional costumes of the Sami people, and used some folk art motifs in his sash. His colors, magenta and indigo, reflect Anna's palette.

"A successful character design entails how a character should behave and act," adds head of animation Lino Di Salvo. "When we first saw Kristoff's design, we felt he might be a bit too elegant, and we had to make it more real. There's a wear pattern on one knee of his pants because he rests on that knee to secure Sven's reins. As animators, we reverse-engineer: his boots are probably this heavy, so when he bends down, he'll bend a certain way that will become a personality trait. The characters should feel like they live in this film. They're not characters from any other movie. They respond to the situations in this film."

Supervising animator Randy Haycock drew one test of a very awkward Kristoff trying to make small talk with Anna. "When I'm animating a character, especially a

male character, I look for traits I can identify with," he says. "Kristoff really wants to be an ideal guy, but he's very aware that he's not. So he's trying too hard. He fidgets and takes his hat off and puts it back on. I was always uncomfortable talking to girls, so I got that part of the character.

"I can draw Kristoff pulling his hat on and off, but in CG, you have to make the rig able to do that," he cautions. "The hat becomes a piece of cloth, and you have to decide how to detach it from his head. These tests reveal things that they may need to address later on. They can save time by rigging it to do the things in the test."

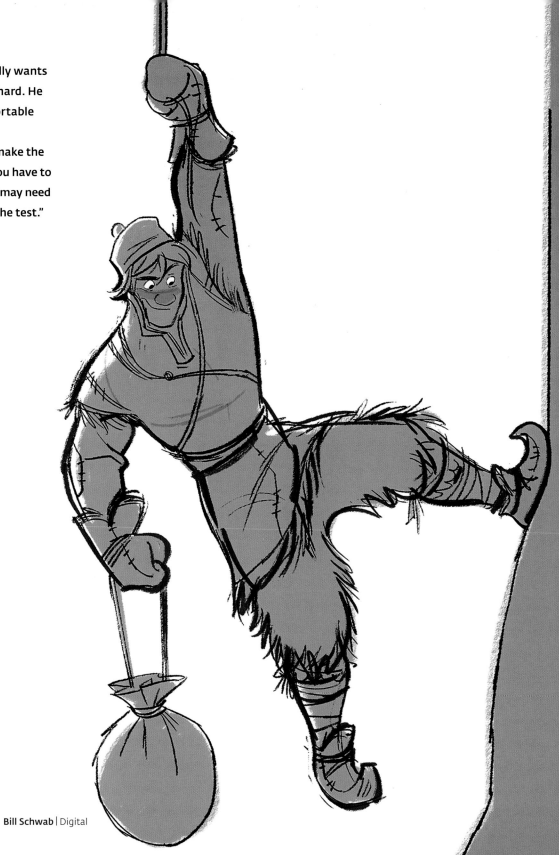

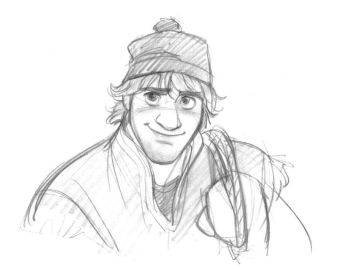

Jin Kim | Digital

Bill Schwab | Digital

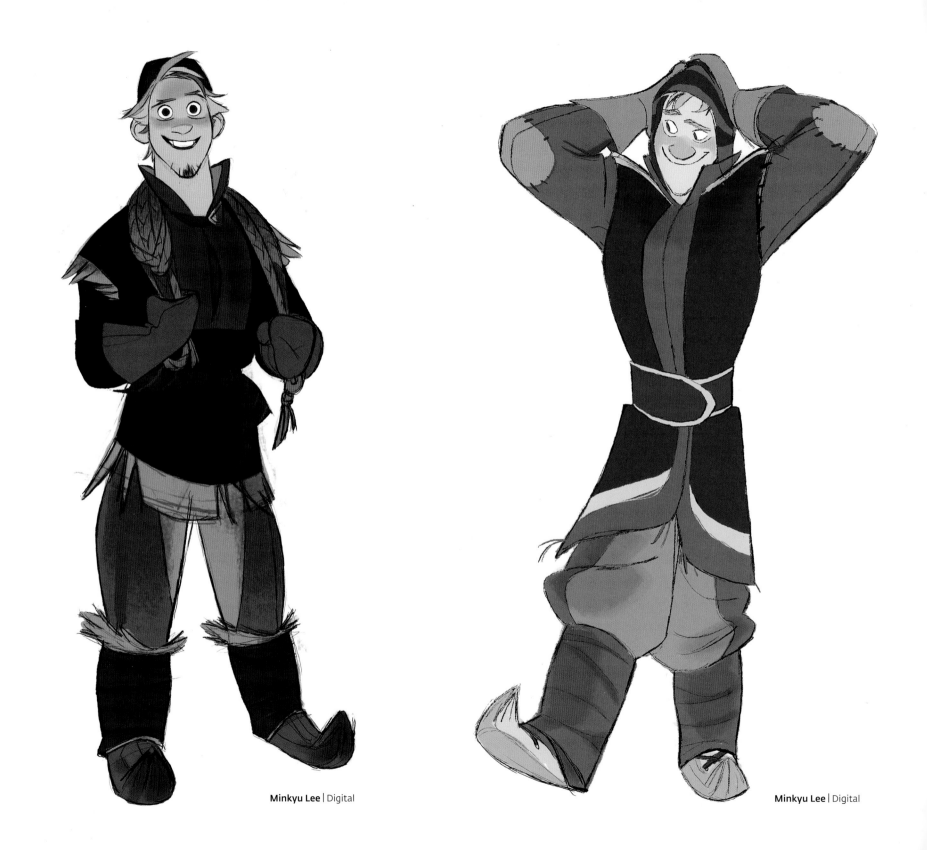

Minkyu Lee | Digital

Minkyu Lee | Digital

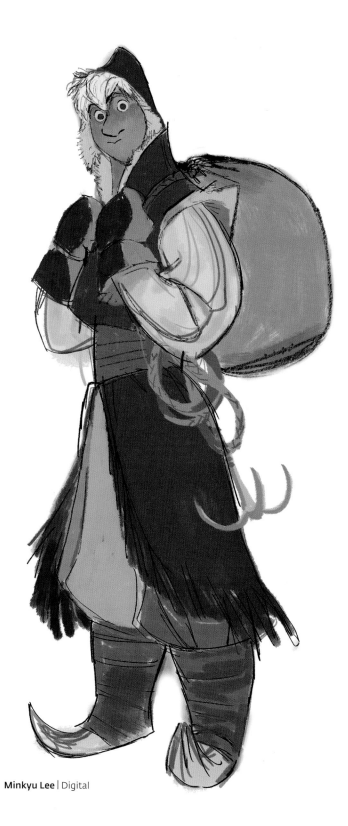

Minkyu Lee | Digital

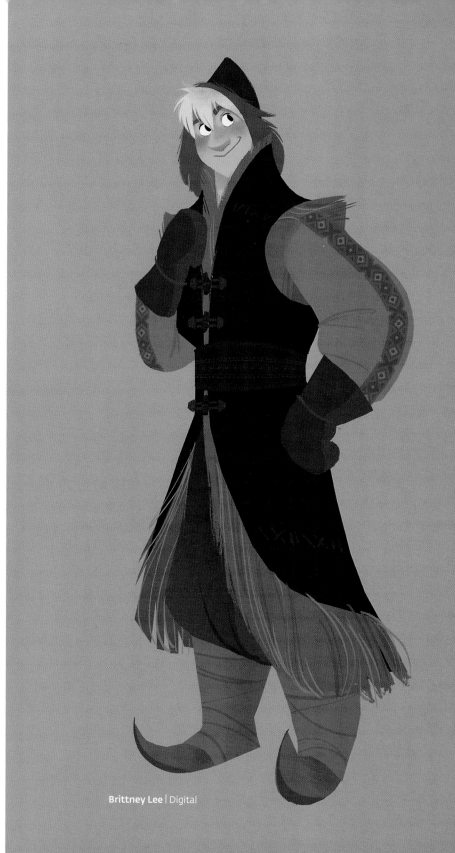

Brittney Lee | Digital

Sven

To emphasize Kristoff's unkempt appearance, the artists are made Sven a more realistic reindeer: a dumpy, unprepossessing animal, unlike the prancing pseudo-horses who pull Santa's sleigh in cartoon Christmas specials. "Sven's definitely not regal," says head of animation Lino Di Salvo. "The wear and tear of being out in the wilderness without being brushed lends to the comedy of the character. His brows are very expressive. He doesn't speak, but if he did it would be via his brows."

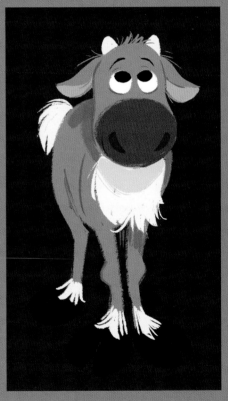

Bill Schwab | Digital

I didn't know what reindeer actually looked like until I got on this movie. I always thought they were the graceful, powerful creatures I saw in the cartoons. I was wrong. I was lied to! My whole childhood!
—Chris Williams, story artist

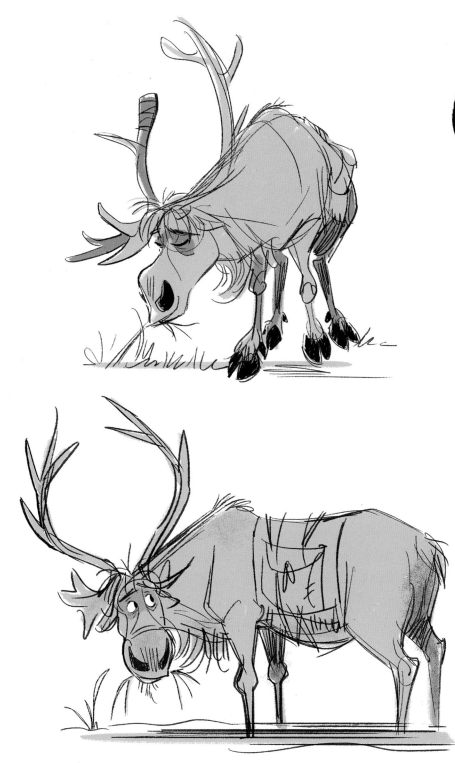

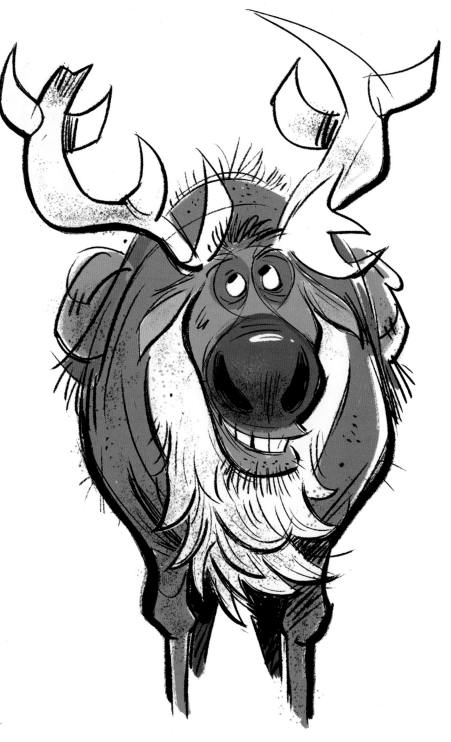

Bill Schwab | Digital

Bill Schwab | Digital

Sven's looking like a pretty dumpy animal. He's my favorite reindeer.
—Clio Chiang, story artist

Cory Loftis | Digital

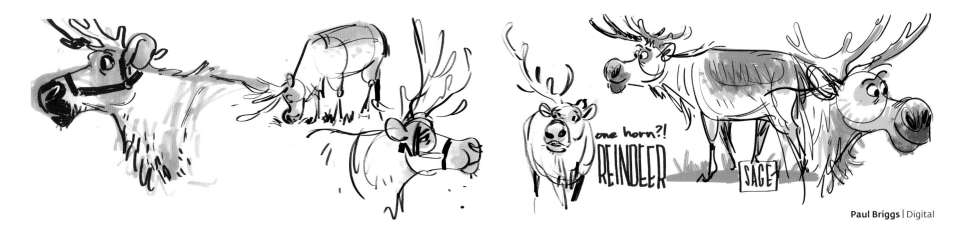

Paul Briggs | Digital

one horn?!
REINDEER

SAGE

An earlier design of Kristoff's sleigh. The idea of Kristoff as an ice harvester came relatively late in production, so this sleigh was modified to enable him to tote blocks of ice.

Cory Loftis | Digital

Olaf

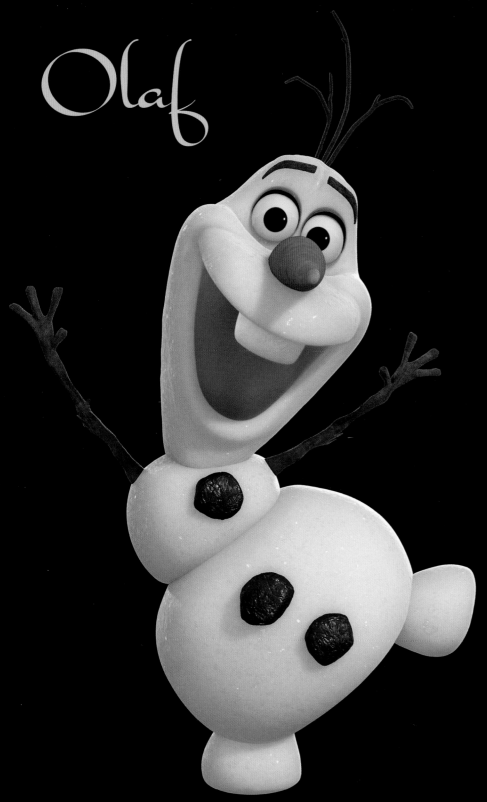

During their trek through the ice and snow, Anna and Kristoff encounter Elsa's formidable snow-guard, and a very different snowman, the ingenuous comic sidekick, Olaf.

"Olaf basically is an exercise in truth in materials," explains head of animation Lino Di Salvo. "At first, we were bending his stick arms and distorting his face too much. He felt like a rubbery cartoon character. Then we thought, 'If snow moved like snow, how would it move? If a character has wooden arms, why not use that limitation as entertainment?' Now you have the character in situations where he has to pop his arm off to reach something, put it back on, take his head and lift it up to look around, because he doesn't have that flexibility."

The artists on *Toy Story 3* complained that Lotso was a difficult character to rig and animate, because a teddy bear has very little anatomy. It's really just an oddly shaped pillow. Olaf has even less anatomy: he's three balls of snow with sticks for limbs.

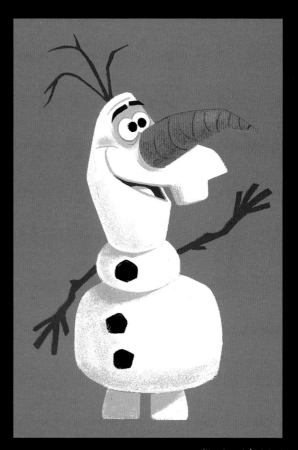

Bill Schwab | Digital

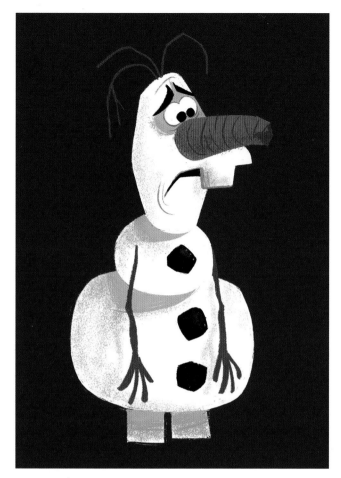

Bill Schwab | Digital

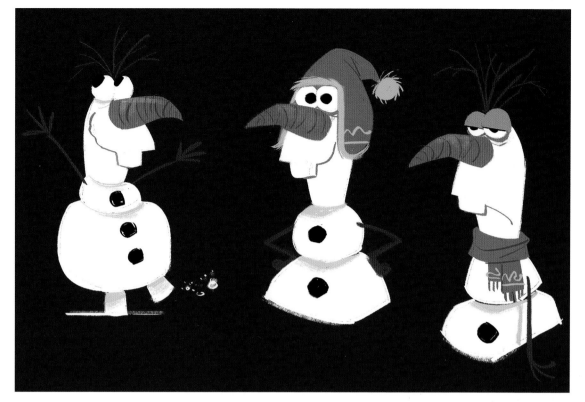

Bill Schwab | Digital

John Lasseter is a big proponent of truth in materials. Olaf has sticks for arms, and he has sticks for eyebrows. How far can we push those shapes without the audience ceasing to believe they're sticks? It's a challenge for the people animating Olaf. —Victoria Ying, visual development

Bill Schwab | Digital

With Olaf, simplicity is key. We don't want him to feel like a stretchy, bouncy, all-over-the-place character. He's a snowman; we can pull him apart and put him together. But we want to keep it simple. To me, Olaf, is my five-year-old boy at home: loving and trusting and pure and very naïve.
—Hyrum Osmond, supervising animator

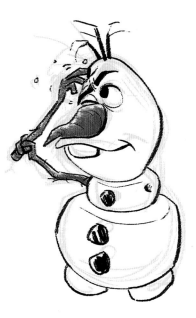

Olaf needed to be able to fall apart, reassemble in any conceivable way, melt and move like snow. We were able to achieve these goals with an easy-to-use rig that was designed with the animators needs in mind.
—Matthew Schiller, character technical director

Hyun-min Lee | Digital

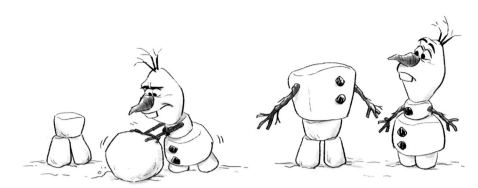
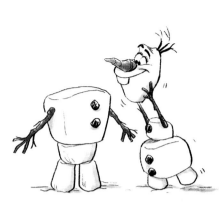

Hyun-min Lee | Digital

"Chris had some ideas about how he wanted Olaf and the other snowmen to look and move early on," says character rigging supervisor Carlos Cabrol. "We'd never done a snowman. It required a lot of back-and-forth with animation: we would prototype something, they would test it, and Chris would ask, 'Can we see him come apart, or have his head fall off?' All the capabilities the animators wanted are in there to make him move and behave in ways humans and animals don't—and can't."

With his blithe charm and break-apart body, Olaf quickly became a favorite of the crew. Story artist Jeff Ranjo comments, "He's almost like a baby: He's just been created. He doesn't know that much about the world, so you have to explain things to him you take for granted, just as you would to a little kid.

"He's built in sections, so we play with him getting hit, like Mr. Potato Head," Ranjo continues gleefully. "You can rip his arms off, you can cut his head off, you can make a hole in him. He doesn't care. I love to torture Olaf, because he's a snowman. He doesn't feel pain. I can abuse him and get paid for it."

"He feels quite a bit emotionally, but he doesn't feel pain," counters fellow story artist Normand Lemay. "So you can play with that and it's okay."

The artists concur that one of the high points of the film will be Olaf's song "In Summer" where he happily imagines himself "Doing whatever snow does in summer."

Lead editor Jeff Draheim comments, "Once someone starts singing, you're breaking the bounds of reality. When Olaf sings about a snowman in summer, it's all in his head. We can have a snowman floating in the water. We can have a snowman sitting on the beach. I love the freedom of working on a musical."

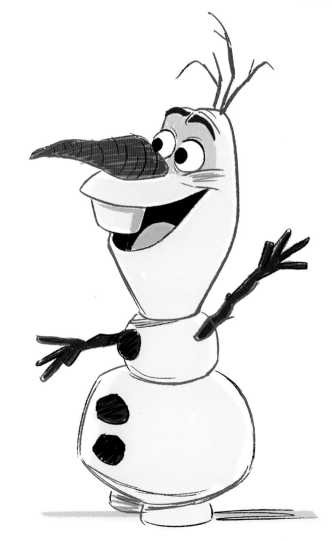

Bill Schwab | Digital

"In Olaf's song, we change the look of the backgrounds to make them more Olaf-like," says Womersley. "It all takes place within the imagination of a strange little snowman. We figured that a lot of the shapes would be Olaf-like, that he would reduce his world to a more Olaf-friendly place."

Despite the challenges, John Lasseter sums up the consensus among the filmmakers when he says, "We have a breakout character in Olaf. The animation of this guy is hilarious. One of the funniest songs I've ever heard is where Olaf, who's always so positive, sings about summer. It's wonderfully naïve. It's the perfect blend of a great voice and writing that comes from the personality of the character."

In addition to his vague anatomy, Olaf posed another difficult problem: how to make a snowman stand out in a snowy environment. Layout supervisor Scott Beattie says, "We can make subtle differences of Olaf's texture, so he doesn't just blend in. And we rely on our friends in lighting to make him stand out."

"'We're going to push the lighting button,'" replies lighting supervisor Josh Staub with a roll of his eyes. "It's definitely going to be hard. We're going to have to make sure he separates from the background, using our traditional techniques of rim and bounce and things like that. But you don't want him to feel like a cut-out. He has to look like he belongs there."

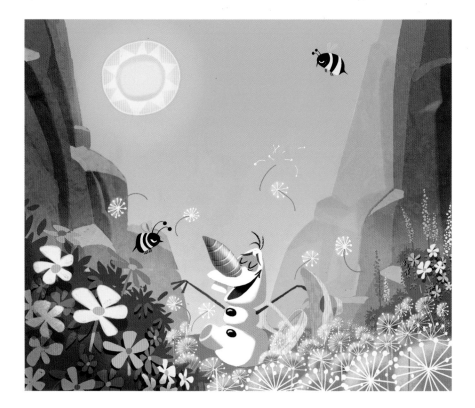

Bill Schwab | Digital

Mac George | Digital

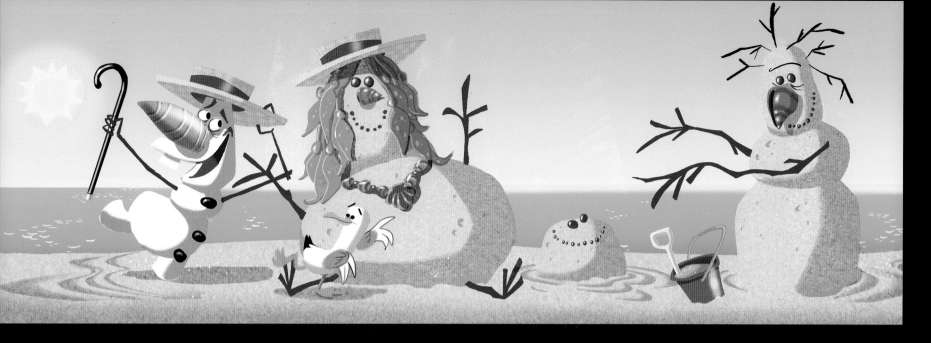

Trolls

A series of hairsbreadth escapes brings Anna, Kristoff, and Olaf to the realm of trolls. But these trolls aren't the dim brutes in the "Lord of the Rings" and "Harry Potter" books. They're magical creatures whose comic appearance belies their ability to discover the truth hidden in each character's heart.

"I love the trolls," says director Jennifer Lee. "With some encouragement from the songwriters, we convinced everyone they belong in the movie. It'll be a unique angle on Trolls."

"You could easily put a barefoot hairy guy with a big nose in there and call it a day, but what is a Disney troll in this movie?" says supervising animator Malcon Pierce. "How do we make them special, and not generic? It's going to be a lot of fun to find that out in the animation, too. They offer the chance to do some pretty cartoony and magical animation."

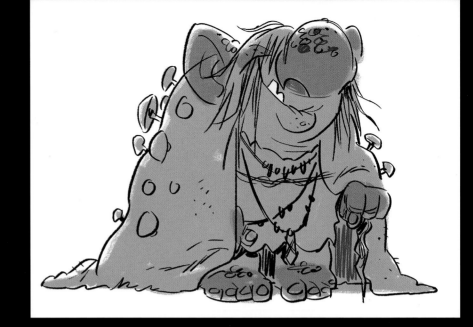

Bill Schwab | Digital

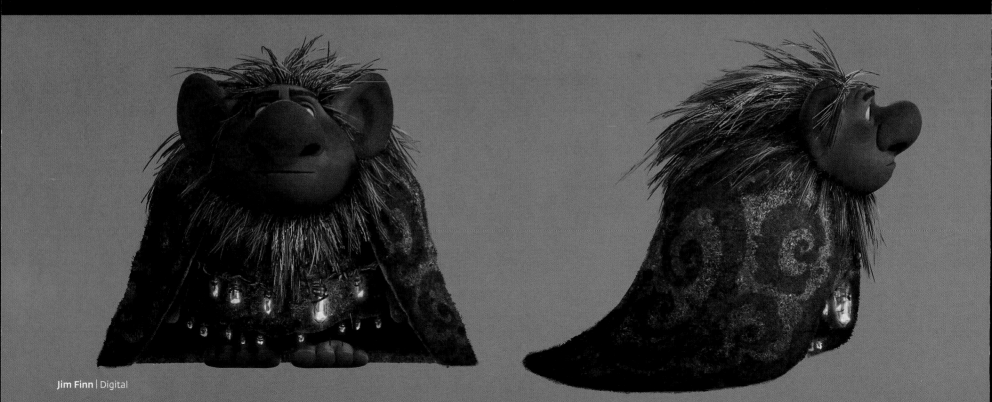

Jim Finn | Digital

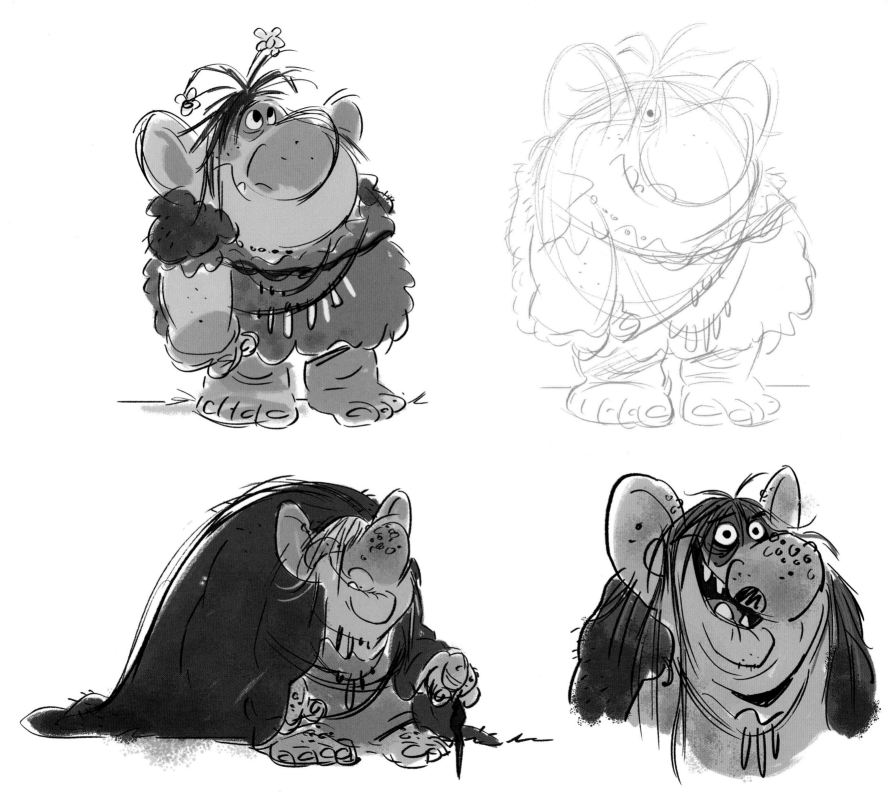

Bill Schwab | Digital

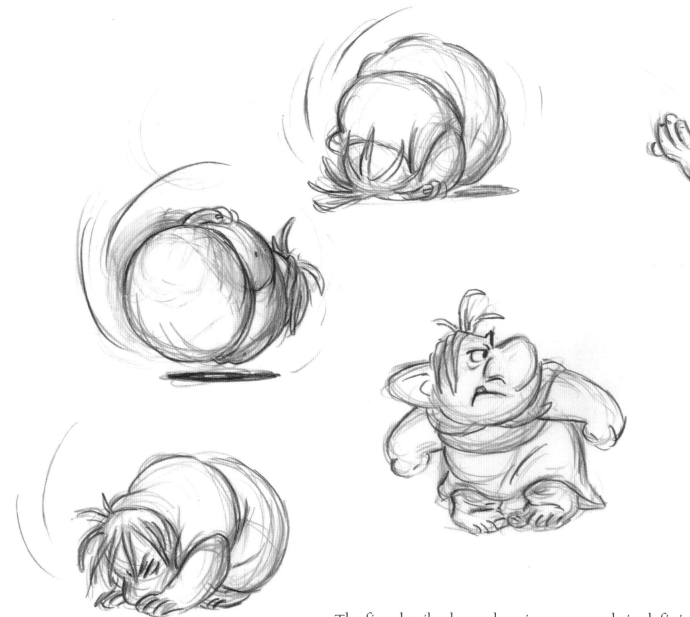

Dale Baer | Pencil

The fine details play such an important role in defining the trolls. Interestingly these details on characters are generally the first to go in a crowd context—they're just not necessary. However we could not remove them as it took away too much from their unique character.
—Moe El-Ali, crowd lead

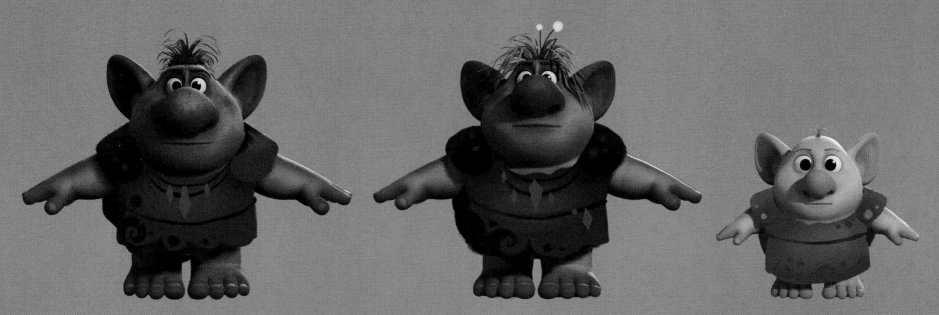

Brittney Lee | Digital

Since the trolls came relatively late into the production pipeline, the design process had to be swift and sure. After settling on an overall design conceit that channeled the round nature of boulders, the next challenge was costuming. Many types of organic floral textures were explored before the final moss garments sporting spiral patterns were decided upon. The spiral motifs were inspired by lichen, yet also reflect an organic variant of the rosemaling motifs used in costuming throughout *Frozen*. The luminous rock crystals that adorn the trolls channel the aurora borealis, thus connecting them to their environment.

Jim Finn | Digital

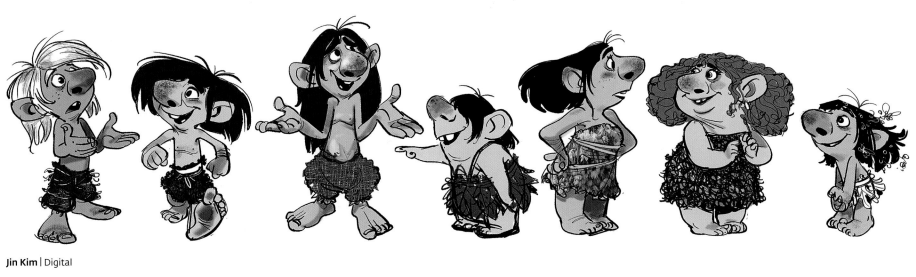

Jin Kim | Digital

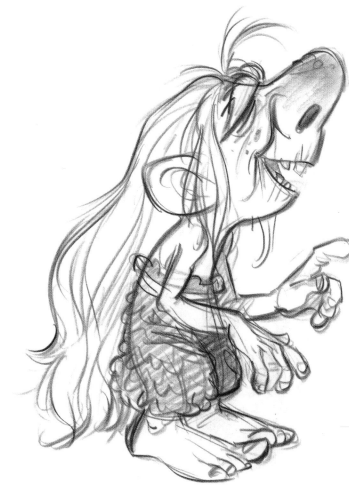

Jin Kim | Pencil

Jin Kim | Digital

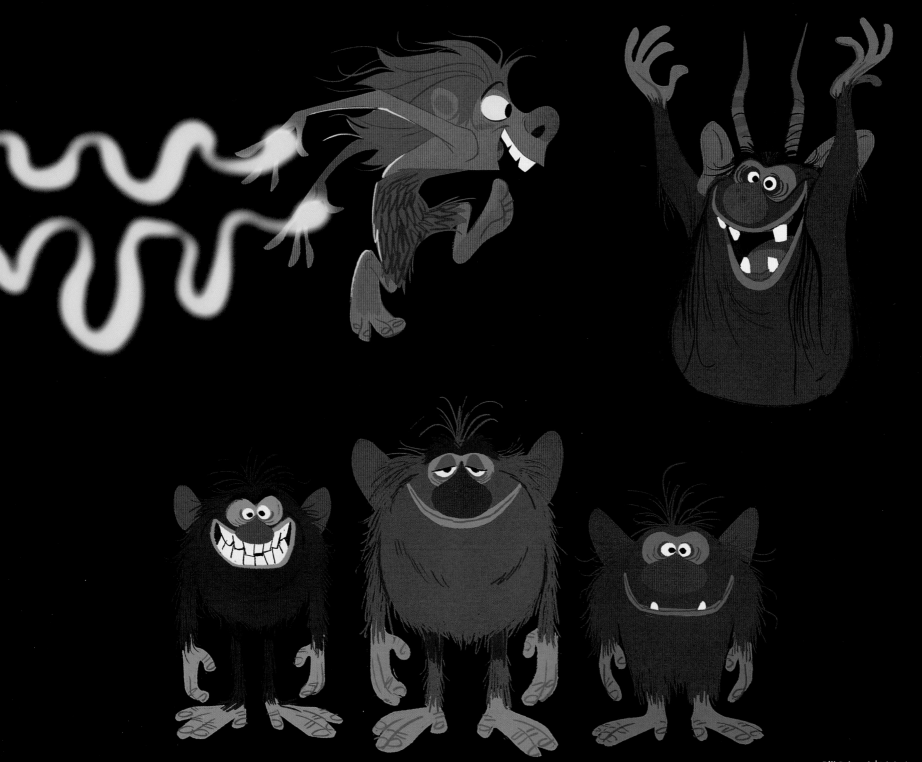

Bill Schwab | Digital

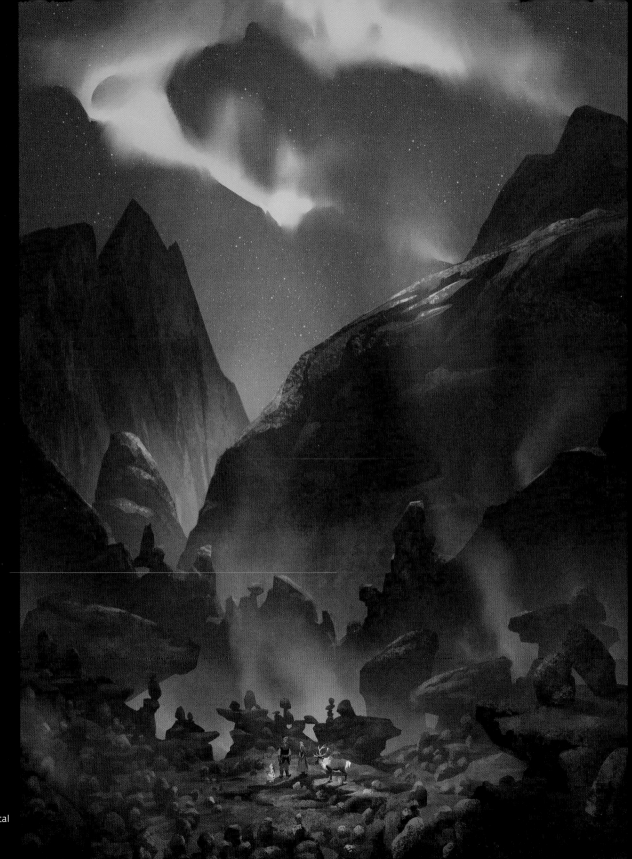

Troll Valley

James Finch | Digital

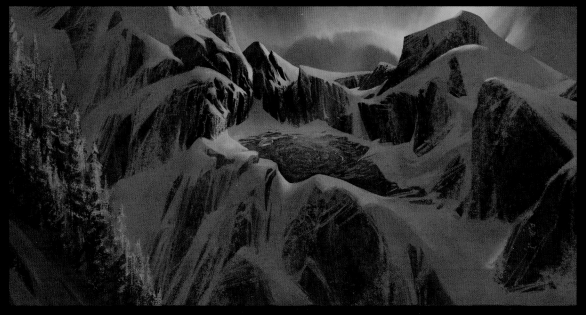

My job is to make sure the background supports what's in the foreground, so we have a good balance of both.
—Jang Lee, visual development artist

Troll Valley

James Finch | Digital

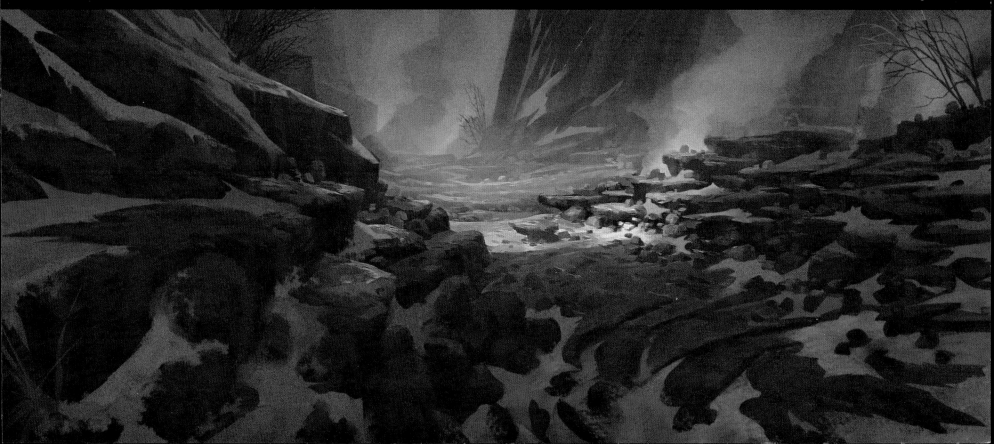

James Finch | Digital

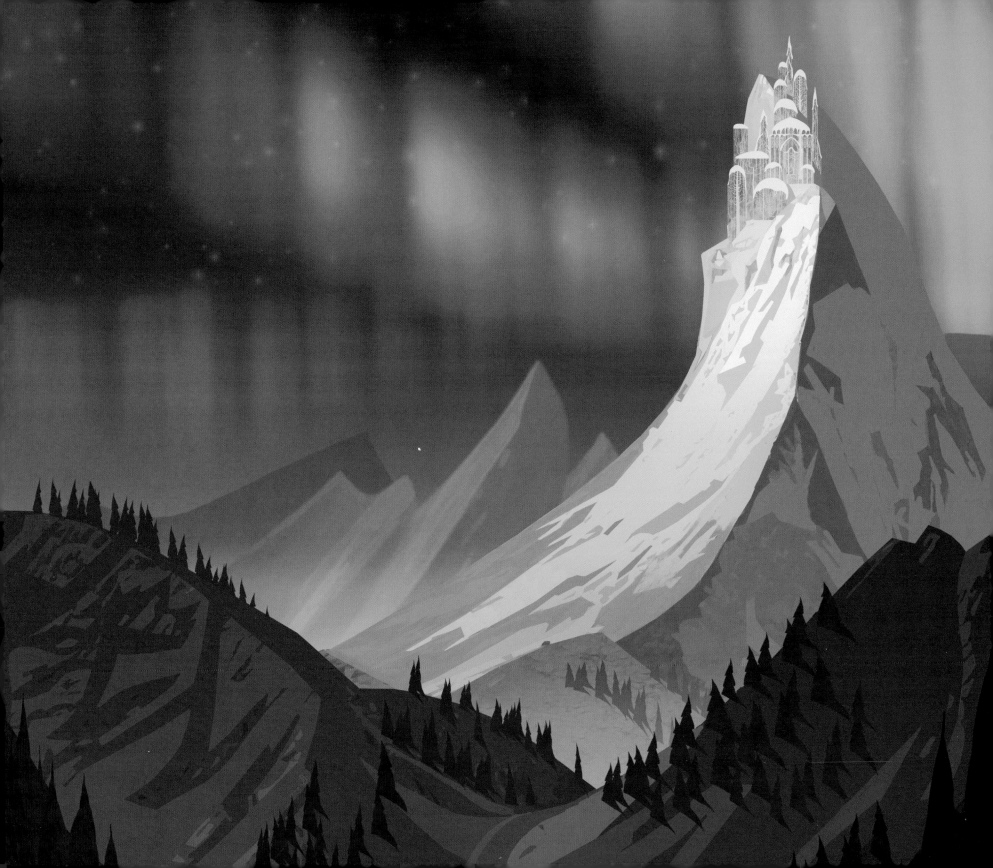

Ice Palace

For Elsa's palace, we can model the ice, we can make it look like ice, it'll be all refractive, and it'll probably take the computers days to render. With ice, everything is shiny, sparkly. How do we make sure things don't get too active, and keep the audience looking at Elsa?
—Mohit Kallianpur, look and lighting director

Alone in the remote mountains beyond Arendelle, Elsa has created an ice palace: a glittering structure that rises around her. For the first time, she has a home suited to her, the Snow Queen.

One of the main challenges the artists faced was creating believable ice, which is more difficult than snow because it's optically active. Its colors can shift according to what's around it; it can shatter light into rainbow highlights; it can appear almost perfectly transparent or completely opaque. Its surface may be glassy-smooth or etched with patterns. It can reflect its surroundings, or distort them like a fun house mirror. Ice isn't easy.

David Womersley | Digital

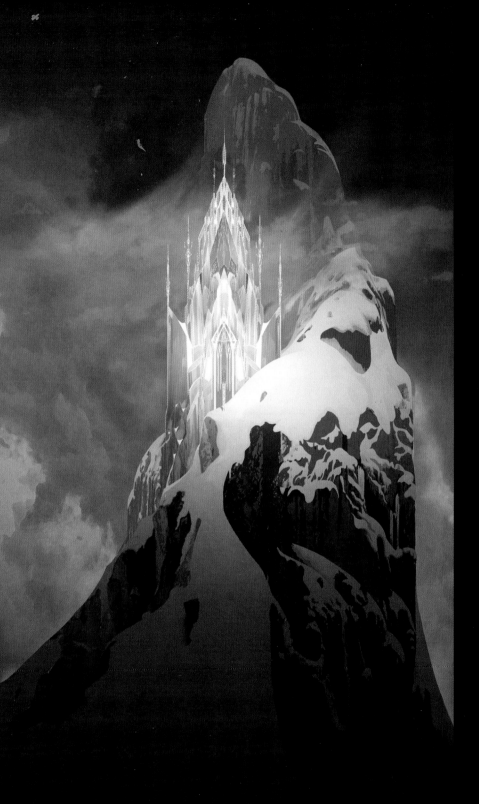

Following John Lasseter's insistence on research and truth in materials, the Disney artists took what amounted to a crash course in meteorology. Effects supervisor Dale Mayeda recalls: "We had Dr. Ken Libbrecht, 'Doctor Snow' from Cal Tech, here to talk about the formation of snow crystals. There's so much amazing stuff about how snowflakes grow, down to the molecular level. Part of our pitch was that nothing ever morphs into a shape or wipes on; everything grows, as it does in nature. Things frozen in storms may assume lyrical shapes that look like something a sculptor created. By doing all this research, we're making magic out of things that actually happen in nature."

A trip to an ice hotel in Quebec City provided further inspiration for Elsa's palace. "They built this thing on ice pillars, and you had opaque snow sculptures with a framework of transparent ice and refractive ice pillars for the whole interior, and some of the exterior walls as well," says production designer David Womersley.

"During the day, the hotel's lit naturally, so you can see the natural qualities of the ice and the snow as light goes through them," adds assistant art director Lisa Keene. "But at night, it's a light show. In the bar, they have two or three different colors that they'd fade out, then a new set would come on. It really messed with your depth perception, because it's basically a white and shiny room, but depending on the value of the light, the space would seem to change."

Although the artists agree that having a drink in the bar was enjoyable and instructive, they declined to spend a night in the hotel's frigid rooms. Seeing a real ice structure helped them to imagine a grander palace.

The ice is going to be a challenge, because it provides a lot of activity, perhaps in areas that you might not want. It's so striking and beautiful, like a roomful of diamonds: as an audience you're going to want to look at it. We have to control it so it's always directing your eye the way we want you to look.
—Lisa Keene, assistant art director

David Womersley | Digital

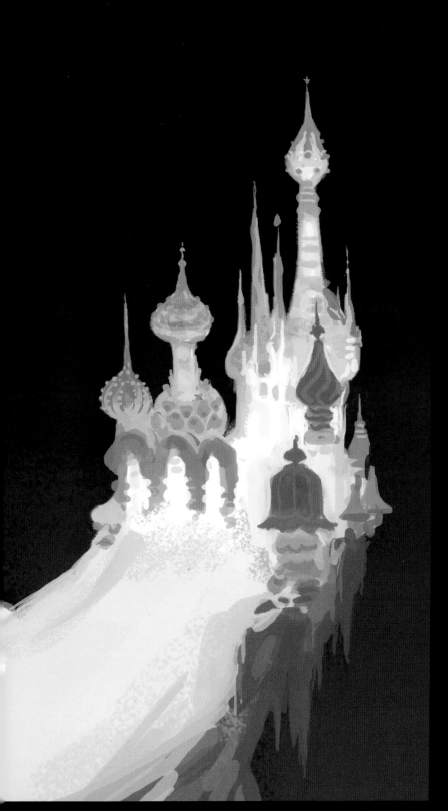

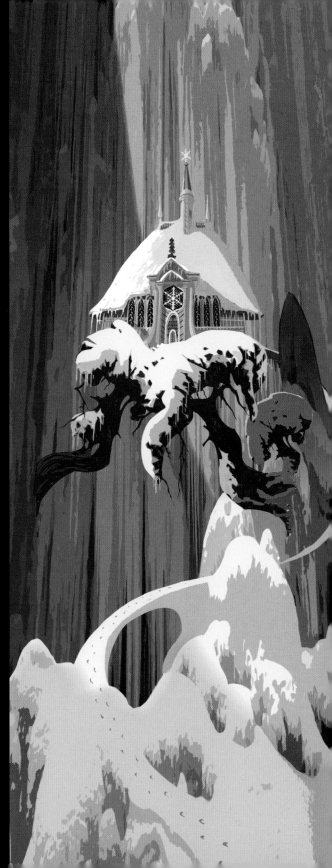

Scott Watanabe | Digital

David Womersley | Digital

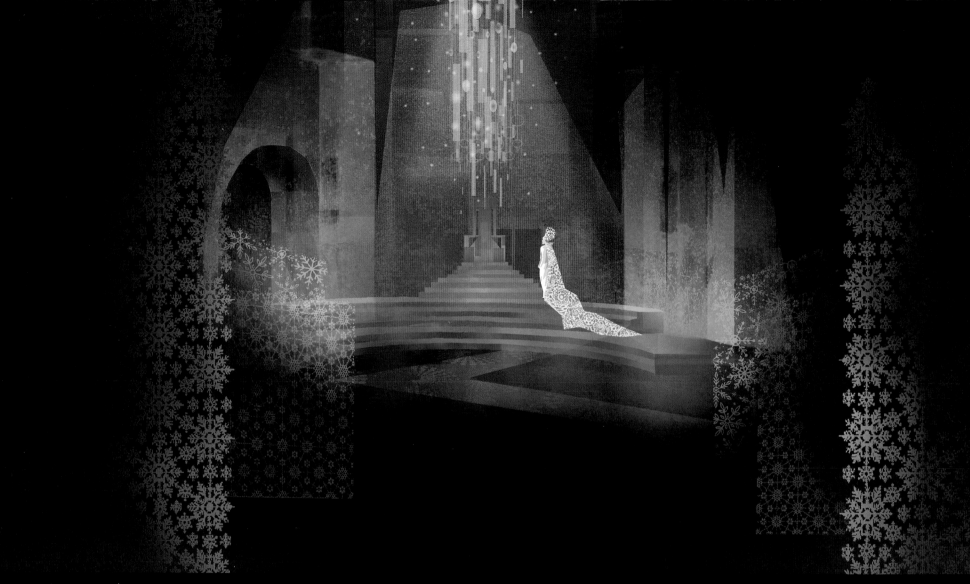

Julia Kalantarova | Digital

"There's ice that's clear and very reflective, and there's ice that has frost on it, through which you see nothing," comments visual development artist Jim Finn. "We'll have areas we want clear, so the audience can see distorted images or reflections. There'll also be frosted parts we don't want the viewer to see through. Sometimes it depends on how cold we want it to be. When it's colder, you don't see wetness or reflections. It's going to reflect the story and how we want it to feel."

The real properties of ice and snow are ultimately less important than how they can be used to advance the story. Visual development artist Cory Loftis adds, "We have normal ice, just like we have in the real world, then there's Elsa's

magical ice. There are two different sets of shapes and colors. Deep ice has really strong blues as opposed to thin ice, which is grays and whites. I focus on the colors and the shapes more than the physical properties of ice."

As Loftis notes, there had to be natural ice and magical ice, but both had to appear equally believable. To keep the audience in the world of the film, the artists felt they had to avoid effects that felt too familiar.

"Michael Giaimo and I didn't want to have that 'Christmas Special snow,' where a giant snowflake wipes the screen," says effects artist Dan Lund. "Snowflakes are beautiful, but unless you zoom in, you never see them. We use

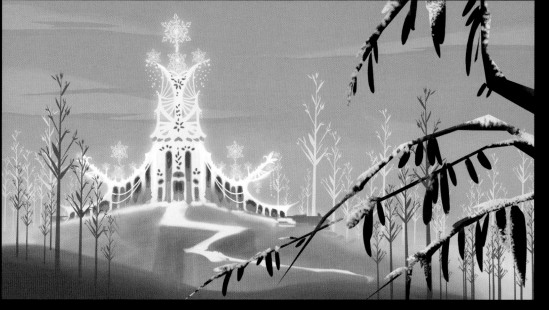

W. Park | Digital

It's fascinating to see how beautiful snowflakes are. If you look at the interior, the floor, and the columns, the ice castle is all based upon the science of snowflakes.
—John Lasseter

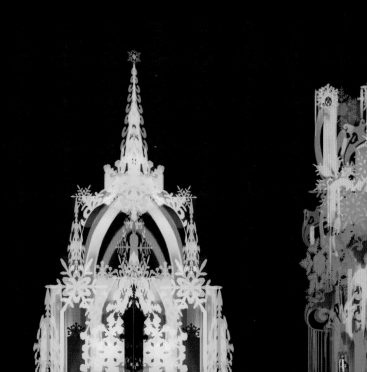

In a live action film, you may have real snow falling on a real actor, and there's believability right off the bat. We're taking believability one step further away by having characters break into song, and build palaces. It demands a higher level of believability, not reality, so that the singing and dancing doesn't take you out of the story. You would think it would be liberating, but it's a bigger hurdle: it makes believability that much more important.
—Marlon West, effects supervisor

Kevin Nelson | Digital

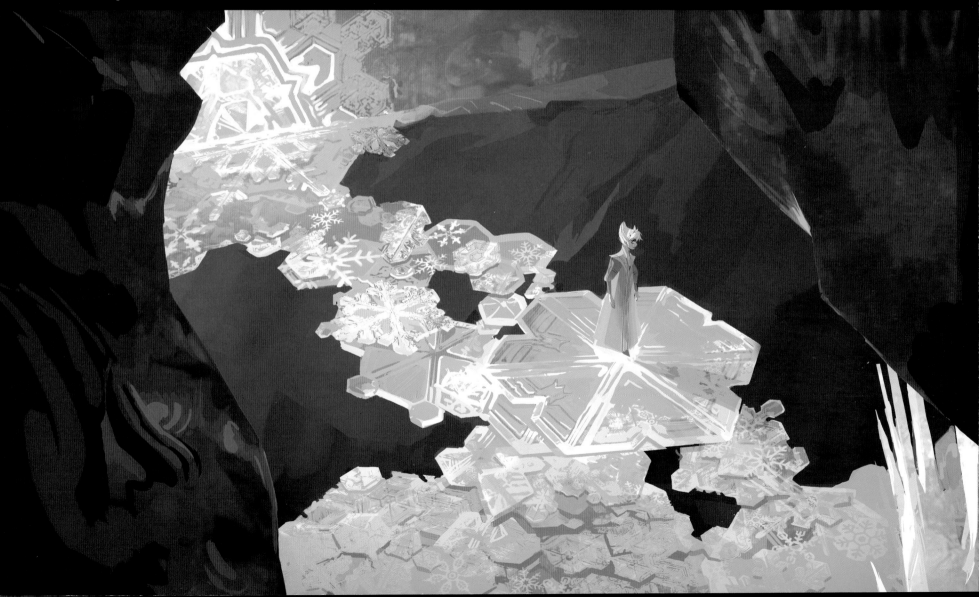

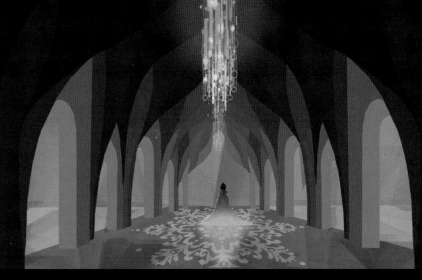

the negative and positive space of snow flurries to create snowflake shapes. We also came up with the idea of having Elsa have a signature snowflake shape. If you saw it anywhere in the movie, you'd know it wasn't nature, it was her."

"Usually effects are just applied to the film at a specific point," he continues. "But after Mike talked about what he hoped the film could be, we came up with effects that had a beginning, a middle, and an end: it felt more like you were pitching a story point than just an effect. That was pretty exciting."

Effects supervisor Marlon West adds, "There's been *Pinocchio* pixie dust; there's been characters like Frozone in *The Incredibles* who shoot snow out of their hands. We don't want to imitate something that's been done, but we have to be on the same page with our character animators. Elsa's not shooting ice out of her hands. She's creating things from the particles in the air. What you see on screen is the result of her magic, not the actual magic."

"Whatever those *Sleeping Beauty*–style sparkles make you feel, I hope you feel it again when you see this stuff," counters Lund.

Womersley stresses that the palace itself reflects Elsa's personality and shifting mood: "In Elsa's song, she goes from being angry and aggressive to more content and lyrical. She's gone to the top of the mountain; she's free to be her real self. Her initial reaction may be aggressive, but once she feels content, the ice and snow structures she creates will become more sculptural."

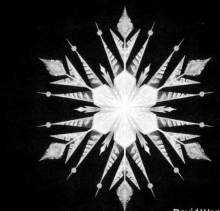

Making those visions appear on the screen would require hours of rendering time. Lighting supervisor Hans Keim sighs, "The ice palace is going to be a major challenge for us, since refractive objects take a really long time to render in CG. How we're going to light it is another challenge, because it's clear ice. How does it reflect the light?"

"Hopefully we'll find a way to bend the rules of physics so we have a rich, believable world that the viewer feels is ice, but without paying the freight for physical accuracy," adds lighting supervisor Jason MacLeod. "The computer offers the ability to pick and choose from the rich complexity of the natural world."

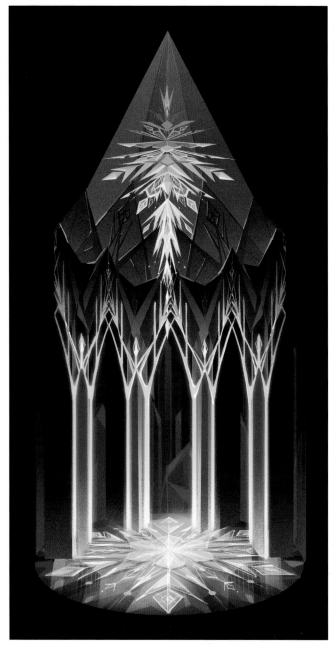

Brittney Lee | Digital

LookDev was faced with the challenge of realizing the looks for snow, ice, and the combo of snow and ice. There are so many aspects to the looks as well, such as geometric snow next to painted snow, snow shapes, and snow sparkles. We wanted to make sure the look was stable, renderable and art-directorable.
—Hans-Jorg Keim, look development supervisor

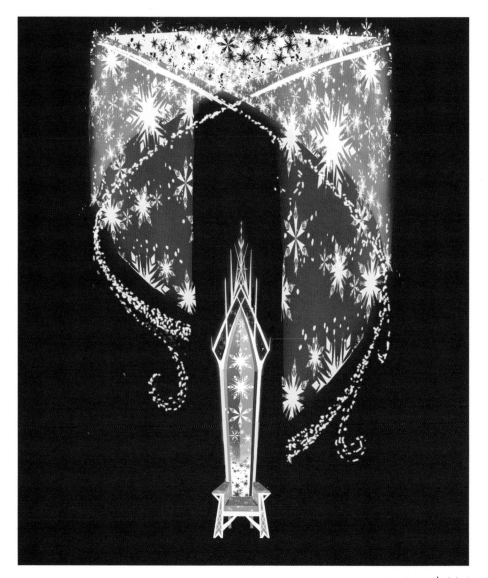

Mac George | Digital

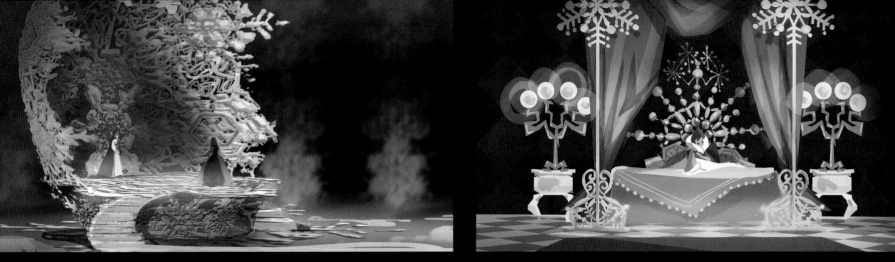

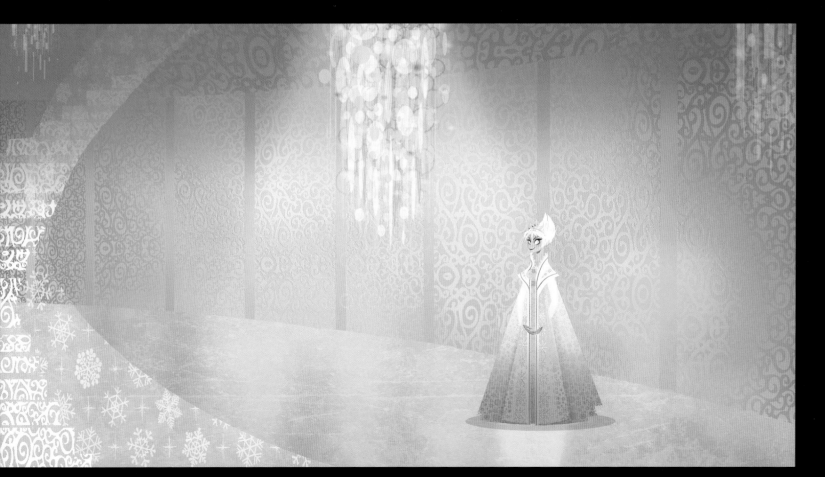

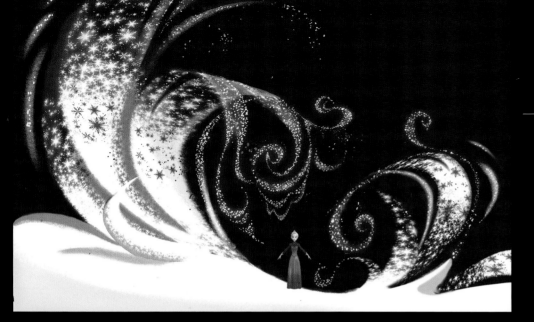

They spent a lot of time looking at snowflakes before we even started on the movie. Elsa's magic ice follows those snowflake patterns, but on a much bigger scale. The way it grows is less chaotic and more melodic or rhythmic.
—Cory Loftis, visual development artist

Mac George | Digital

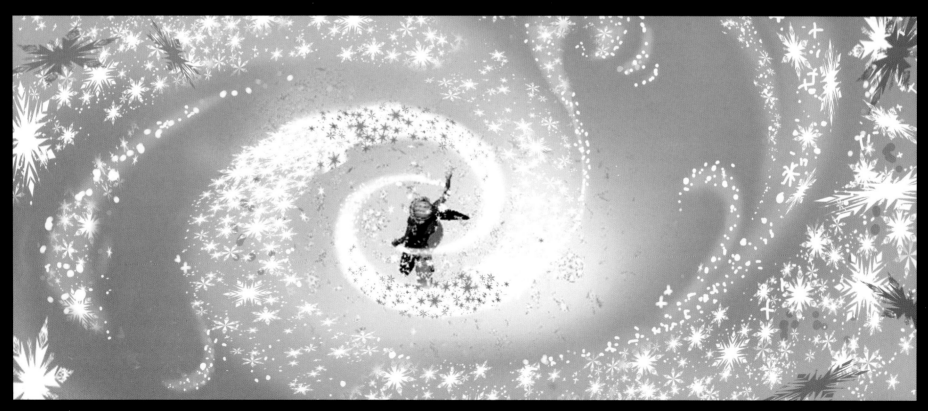

Mac George | Digital

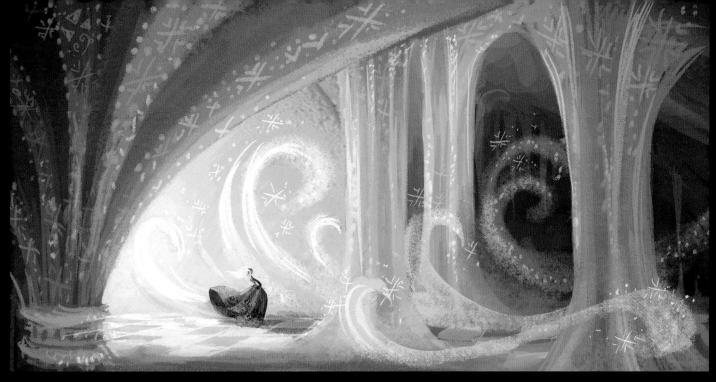

Claire Keane | Digital

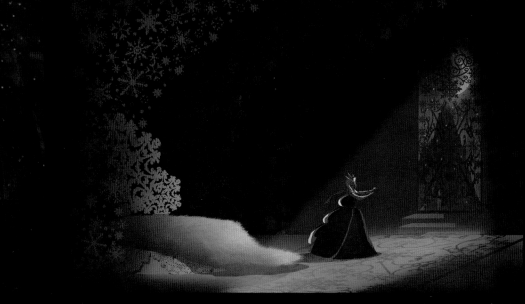

Lisa Keene | Digital

Julia Kalantarova | Digital

131

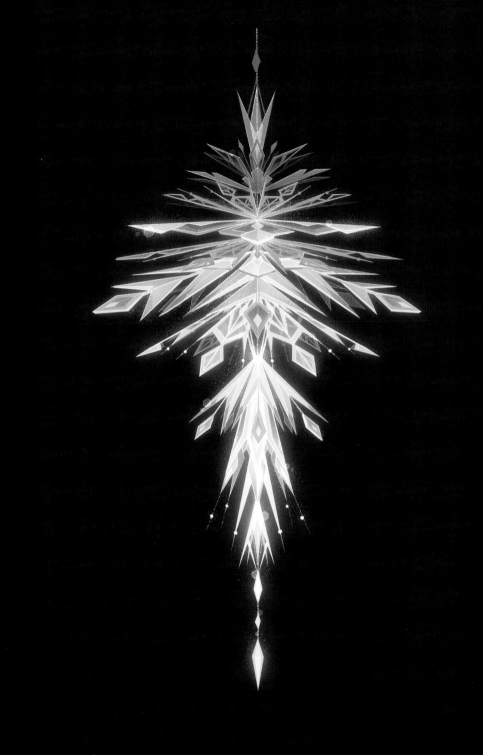
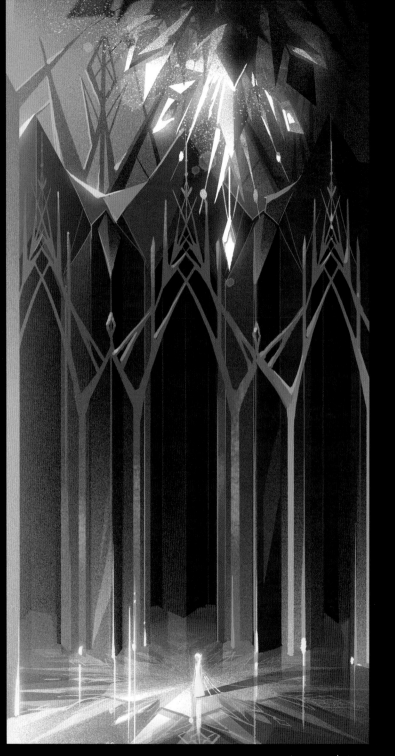

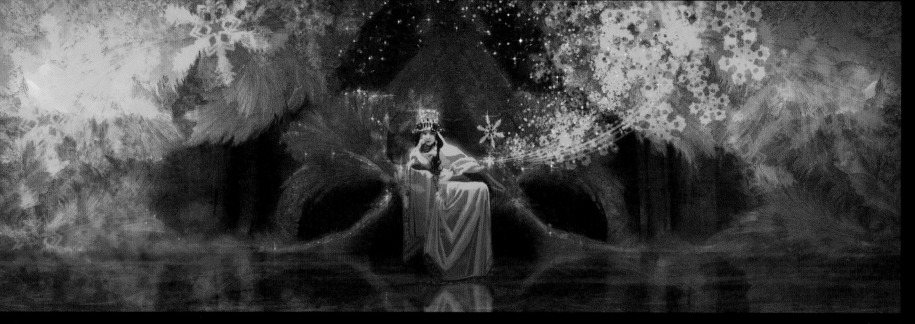

Lisa Keene | Digital

John Lasseter's directive for the ice palace was to make it a celebration of the hexagon motif found in all snowflakes. Brittney Lee beautifully exploited this conceit with all the interior architectural elements. —Michael Giaimo, art director

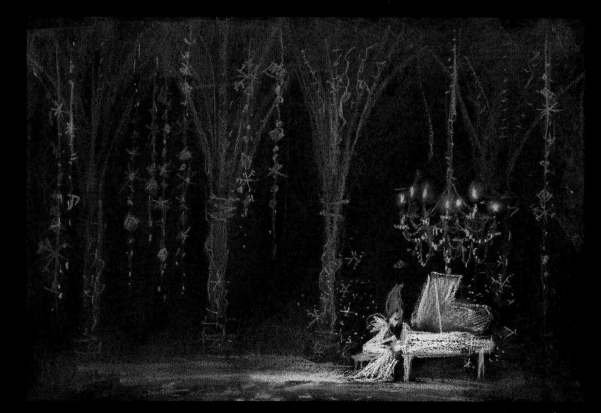

Claire Keane | Pastel

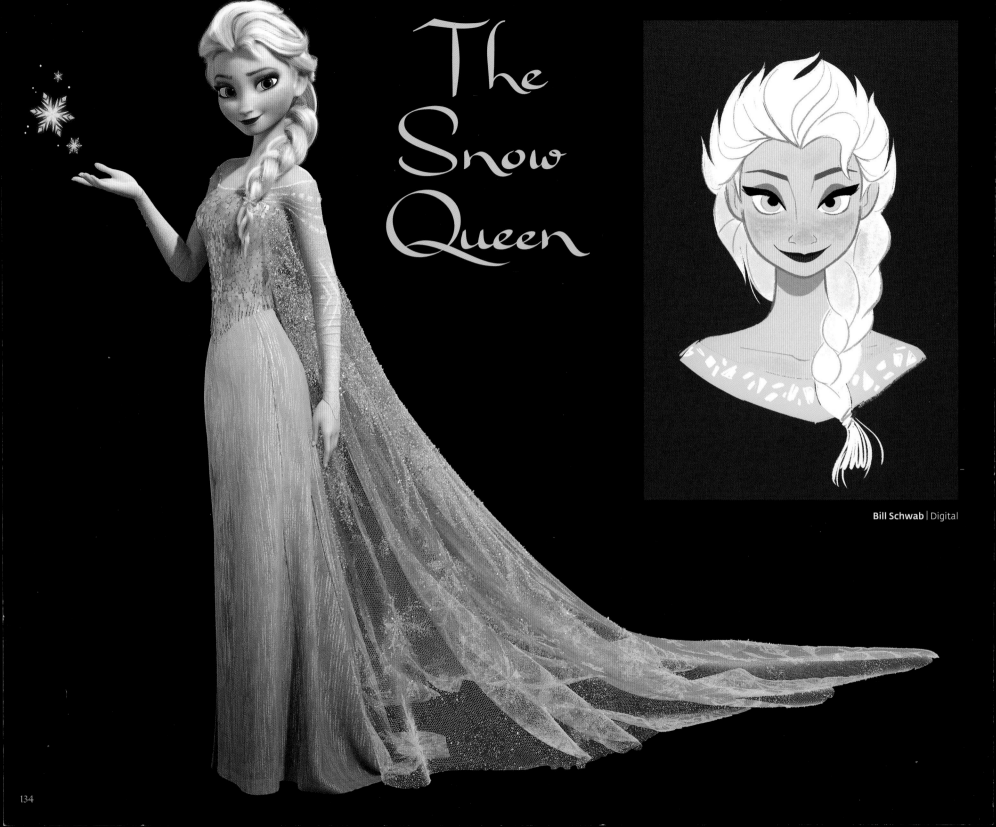

The Snow Queen

Bill Schwab | Digital

Brittney Lee | Digital

For Elsa's cape, they want to have a crisp, almost unrealistic triangle shape to it. Gravity would probably dip the cape down, but they want to retain it. The question is, can we pull that off and not have it feel distracting.
—Wayne Unten, supervising animator

I had worked with Jin Kim on *Tarzan*; his draftsmanship is just gorgeous. He's done a lot of character designs, doing some beautiful drawings, then giving them to the CG animators or the modelers so that they can get the appeal of the hand-drawn.
—Chris Buck, director

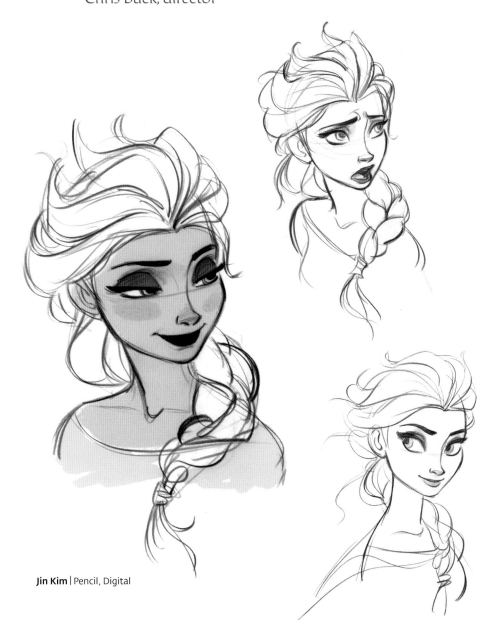

Jin Kim | Pencil, Digital

Michael Giaimo | Acrylic

Bill Schwab | Digital

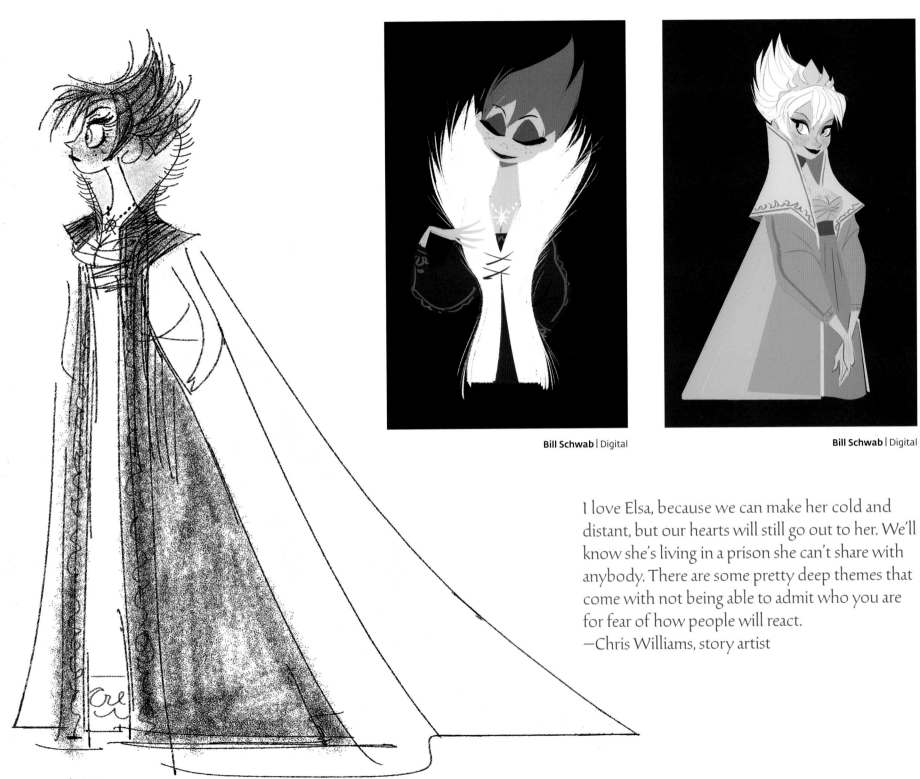

Bill Schwab | Digital

Bill Schwab | Digital

I love Elsa, because we can make her cold and distant, but our hearts will still go out to her. We'll know she's living in a prison she can't share with anybody. There are some pretty deep themes that come with not being able to admit who you are for fear of how people will react.
—Chris Williams, story artist

Bill Schwab | Digital

Michael Giaimo used the word panache to describe the design sense on *Frozen*, and that's Elsa to a T, stylish, original, and confident. From the column dress complete with leg slit and train, to the ethereal frost cape that needed to be magical yet believable, to her gorgeous almost flame licked hair. Elsa makes a statement. She embodies many of the challenges for simulation team *Frozen*. Strong sleek shapes, that have purpose and clarity and motion, while accenting and supporting the characters physical and emotional performance.
—Keith Wilson, sim lead

Elsa is like a walking special effect, with a costume design that refracts and reflects like an ice crystal. Her subtle mauve crew neck top, icy blue cape, and warm blue dress are an exquisite symphony of color, pattern, texture, and form.
—Michael Giaimo, art director

Brittney Lee | Digital

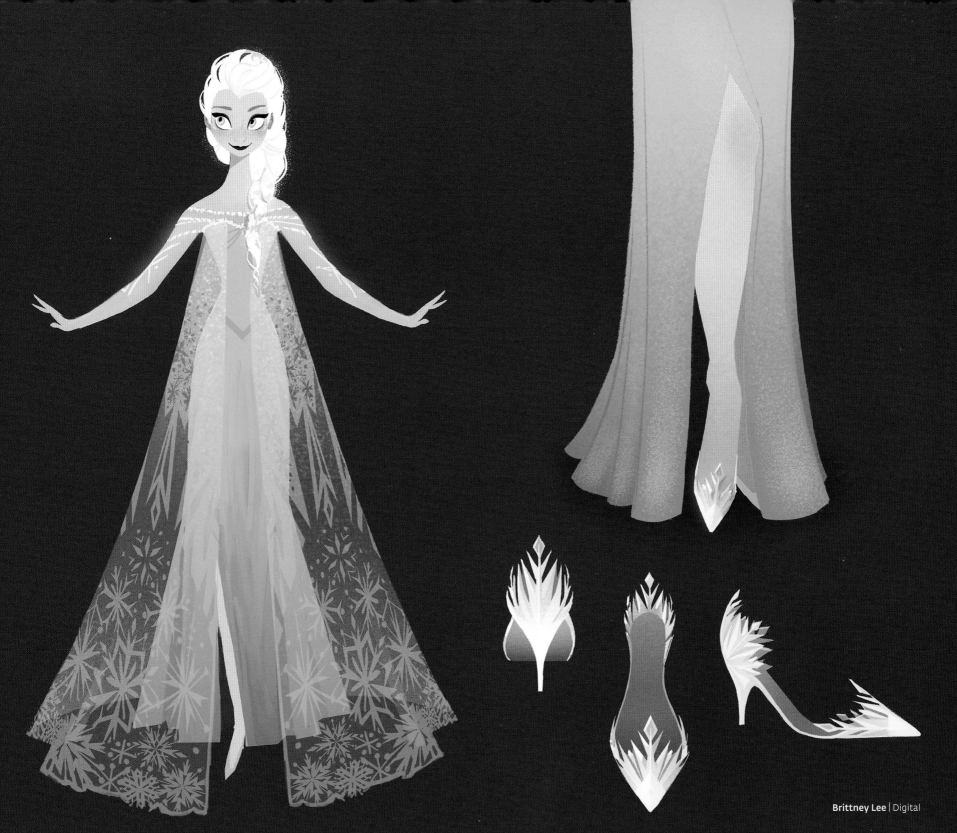

Brittney Lee | Digital

Claire Keane | Charcoal, Pastel

I draw from all the fights my sisters had.
—Hyrum Osmond, supervising animator

Bill Schwab | Digital

Rigging both Anna and Elsa presented a unique challenge as both the film's heroines and also as sisters. They both shared a high level of performance and appeal, and yet each sister required subtle refinement to ensure their distinctive personalities emerged.
—Joy Johnson, character technical director

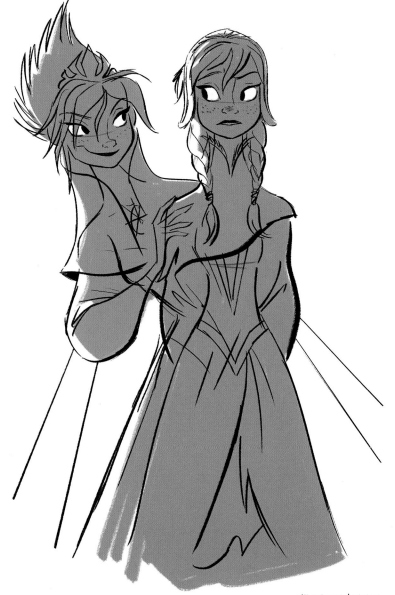

Bill Schwab | Digital

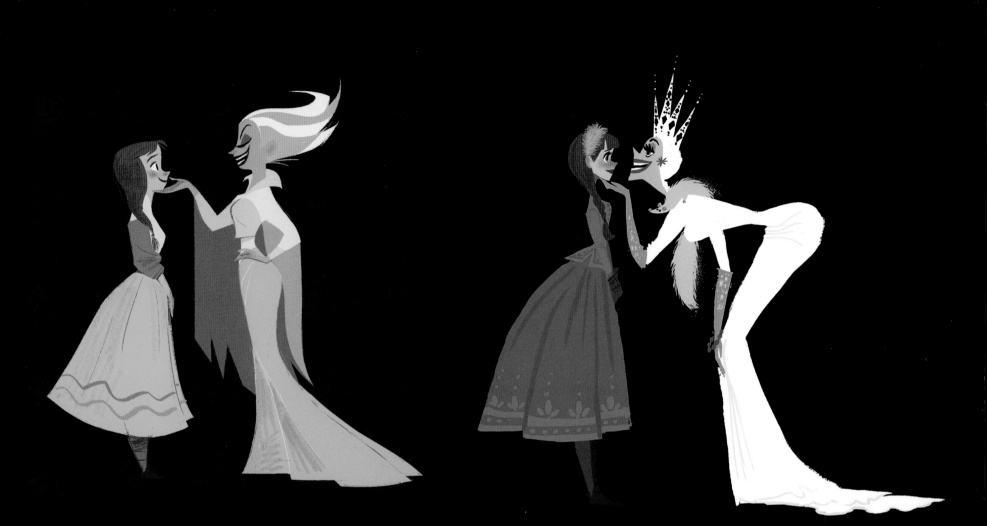

Bill Schwab | Digital

Claire Keane | Digital

Victoria Ying | Digital

Doug Walker | Digital

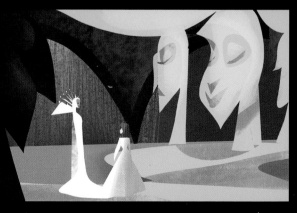

Victoria Ying | Digital

Marshmallow

Cory Loftis | Digital

Modeling characters at Disney has always been a challenge. Modeling characters on *Frozen* like the snow monster was no exception. How do the icicles penetrate into the snow? How hard do we make the edges and plain breaks so they light correctly? How do we prevent this guy from feeling like he was wearing a rubber suit? We must have modeled at least four different monsters before landing this guy. Luckily here at Disney we have some of the best artists in the biz so I'm confident he will put the scare into all the kids watching.

—Chad Stubblefield, character modeling supervisor

Bill Schwab | Digital

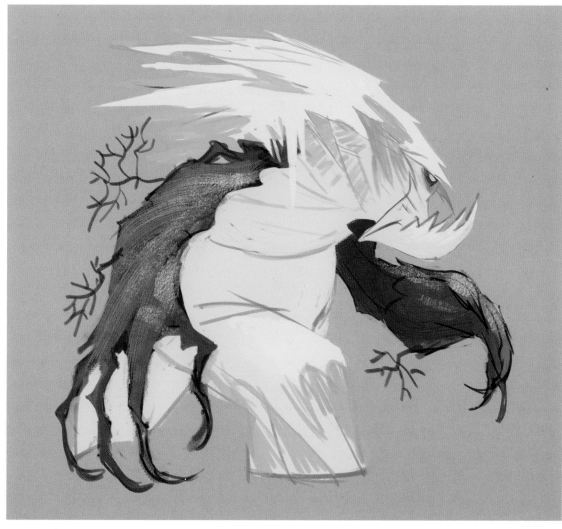

Cory Loftis | Digital

Bill Schwab | Digital

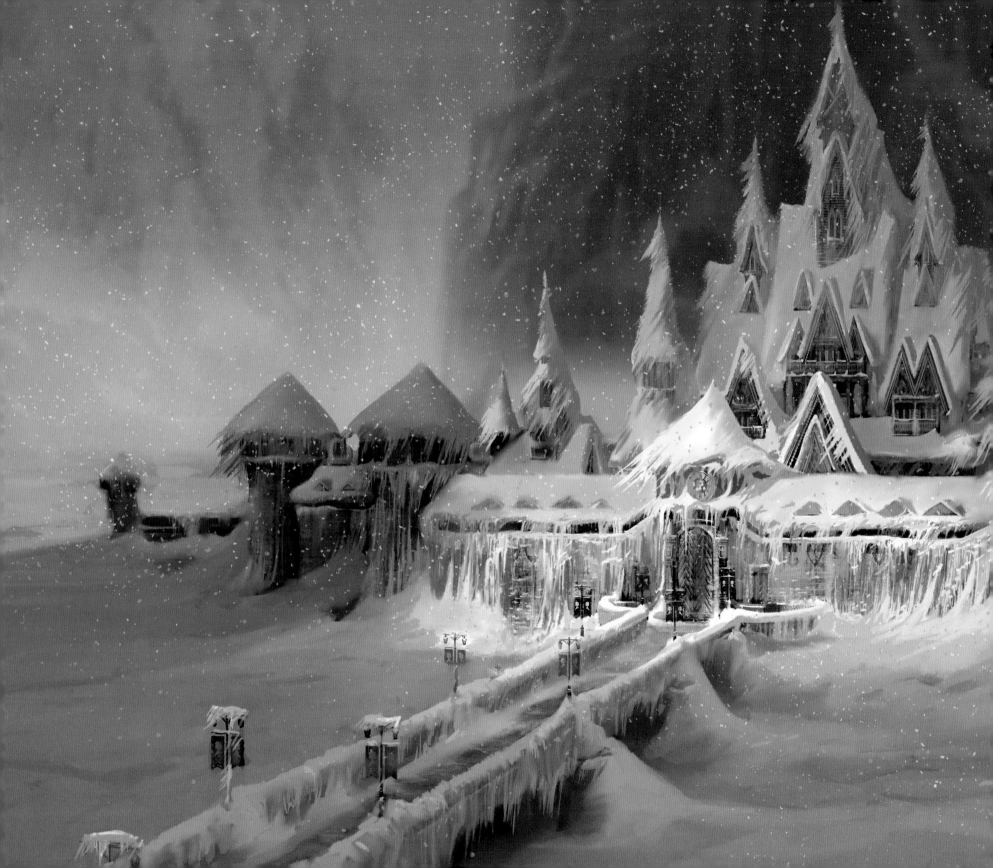

RETURN TO ARENDELLE

One of the unique things about the Walt Disney Animation Studios is you have under one roof brilliant hand-drawn animators and artists, and brilliant computer animators. They work together as a team. We've done a lot of development with drawings, the same way we develop a story with drawings.
—John Lasseter, Pixar/Disney chief creative officer

Defeating Hans's plot to seize the throne of Arendelle brings Anna and Elsa together: love and respect triumph over years of isolation and misunderstanding. For the first time since they were little girls, they can share an afternoon at the skating rink—joined by Olaf, Sven, and Kristoff. Their adventures brought the mountain man and the princess together, despite expectations that Hans was the perfect man for her. The artists symbolize the sisters' renewed bond with a castle that is half wood and half ice.

Everyone involved in *Frozen* stresses that the film is a musical, not just a film with songs. Walt Disney's initial animated features were musicals, and a second series of musicals, *Little Mermaid*, *Beauty and the Beast*, *Aladdin*, and *The Lion King* marked the Studio renaissance of the late '80s/early '90s.

"Once Chris said he wanted to embrace the musical form, it gave me more liberty with the environment, characters, and costumes," says art director Mike Giaimo. "Eyebrows were raised at some of the color choices, but they help suspend disbelief. They let the audience know right away that this is going to be a magical, musical world, so even the most jaded four-year-old will suspend their disbelief.

"I did a lot of research in terms of cinematography and found several musicals that inspired me in terms of how the combination of environment, character, movement, and music worked in harmony," he continues. "*The Sound of Music* bears a close relationship to our environment of mountains, water, and blue skies. Robert Wise took the city of Salzburg and created an exquisite backdrop that enhanced the characters. In *Fiddler on the Roof*, the environments breathe. Since we're dealing with the wide screen on this show, the camera is most effective when you let things breathe."

Director Chris Buck adds, "*Tangled* was a movie with music. I'm hoping the audience is still there for a great musical. Usually, the most emotional, the most dramatic, the most fun sequences in a movie will be the songs. If we make a great movie with great songs, the audience will enjoy it no matter what they call it."

Bobby Lopez, who wrote the hit musical *The Book of Mormon*, and Kristen Anderson-Lopez, who wrote with him the songs for Disney's *Winnie the Pooh* (2011), collaborated on *Frozen*. Buck says, "Bobby and Kristen have a very strong story sense. We may have thought, 'We'll play songs here and here and here,' but it was a lot harder to make the songs part of the structure and not just songs where you stop and sing."

Although John Lasseter didn't work on the Ashman-Menken musicals at Disney, he stresses that a good song can provide concise, emotionally resonant storytelling. Ideas that would become tedious in exposition can be neatly presented through a song.

"Sometimes in a musical, you can stop the plot and explore an emotion with a song, and it's fun: 'Be Our Guest' in *Beauty and the Beast*," Lasseter says. "At other times, you can really see a character develop. Elsa's song 'Let It Go' is just remarkable,

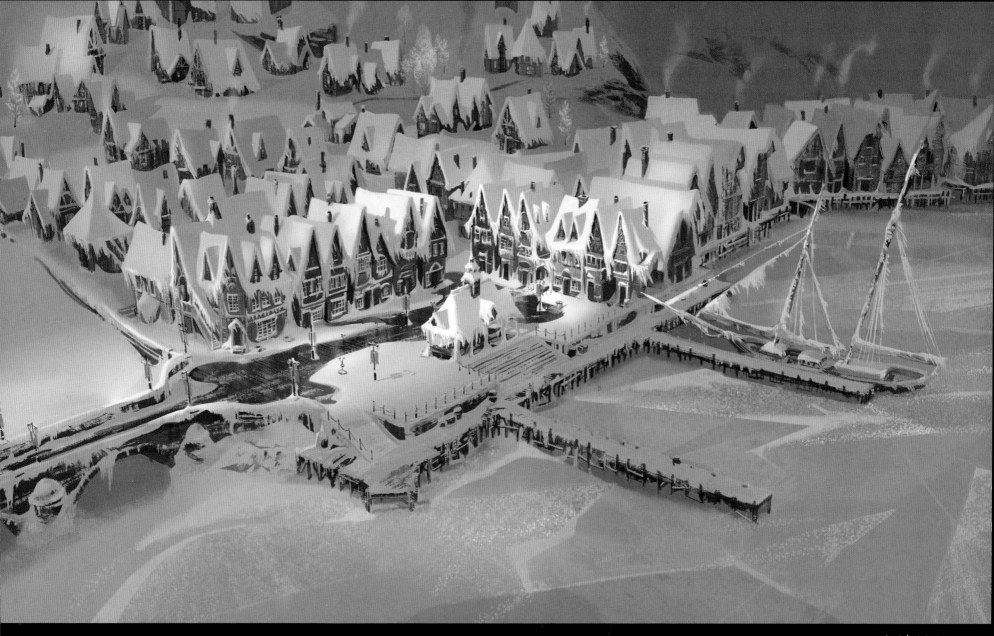

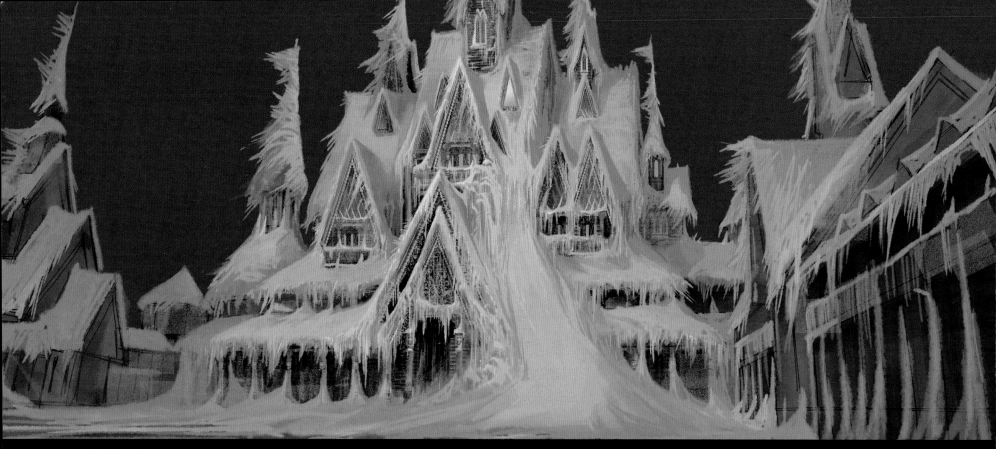

James Finch | Digital

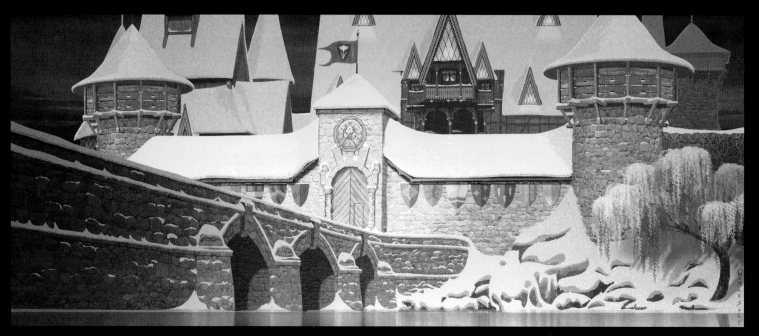

David Womersley | Digital

In the normal winter, you'll have a lot of snow forms. But the harsher Elsa-caused winter is going to have frozen fjords and more extreme forms of ice. We're looking at some of the Great Lakes lighthouses: when they get continually sprayed, ice forms on top of ice, and you get these really bizarre-looking almost, ice sculptures.
—David Womersley, production designer

Cory Loftis | Digital

and Idina Menzel's performance is breathtaking. It would have been completely unbelievable to have a character change that much in a nonmusical setting in that amount of screen time."

When the new Disney musicals became big box office hits, other studios tried to copy the model. The result was a spate of uninspired films where the plot halted, a character sang, and the filmmakers tried to pick up the story.

"By the time the song came, you felt like you'd already heard it," observes producer Peter Del Vecho. "Other studios assumed, you write a song, you put it in the movie, and it's a musical. The only way a musical works is if the songs heighten the emotional beats in a way that grows organically out of the story. Several songs written for *Frozen* were great songs, but they didn't fit into the movie, so they're gone. Similarly, there are sequences we write and board that ultimately don't serve the movie, so we jettison them.

"We're on a video conference call with Bobby and Kristen every day, talking about story—not talking about songwriting, but story," he emphasizes. "They won't write a song until they understand where the story is going. It has to be a continuation of the plot and convey something in a way dialogue can't."

Certain songs are more about a lyrical camera movement, as opposed to one we might do like a Broadway show and not move the camera around much. We're trying to let the songs dictate that. *Tangled* was more of a movie with songs, so we're going take this one to the next level.
—Scott Beattie, layout supervisor

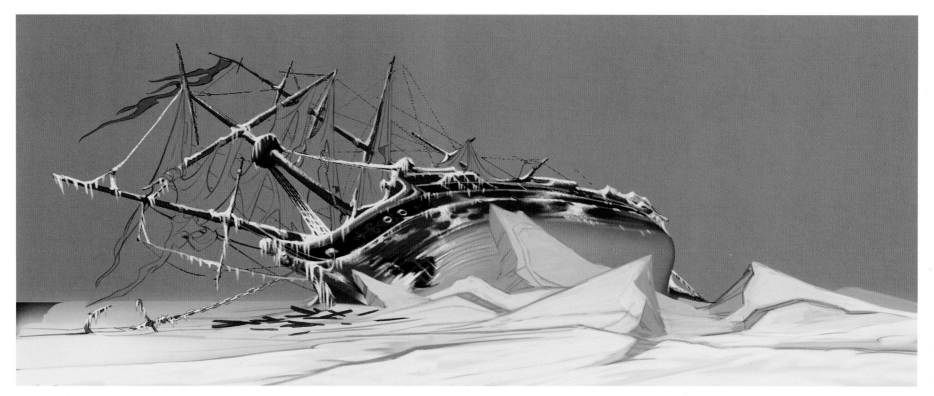

Cory Loftis | Digital

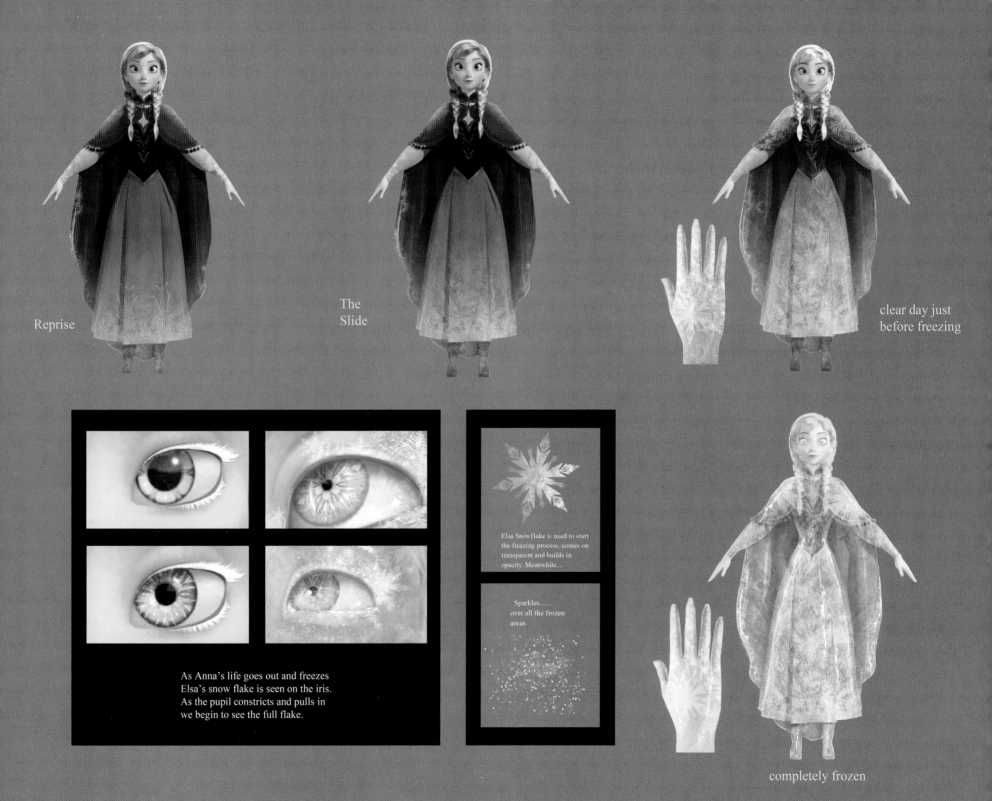

Reprise

The
Slide

clear day just
before freezing

As Anna's life goes out and freezes
Elsa's snow flake is seen on the iris.
As the pupil constricts and pulls in
we begin to see the full flake.

Elsa Snowflake is used to start
the freezing process, comes on
transparent and builds in
opacity. Meanwhile...

Sparkles........
over all the frozen
areas

completely frozen

Anna Freezing chart

Lisa Keene | Digital

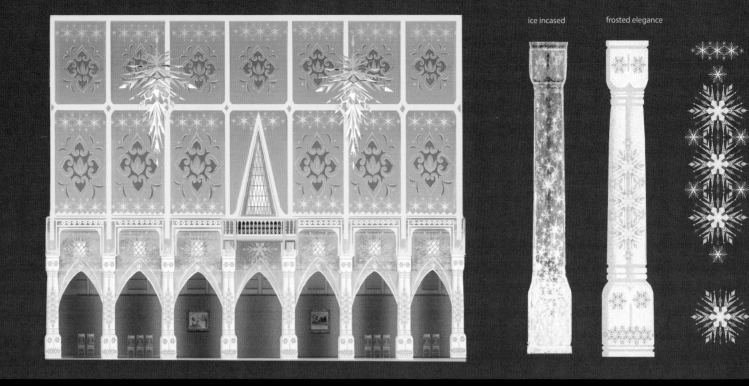

ice incased frosted elegance

James Finch | Digital

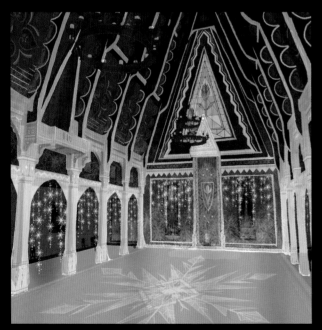

James Finch | Digital

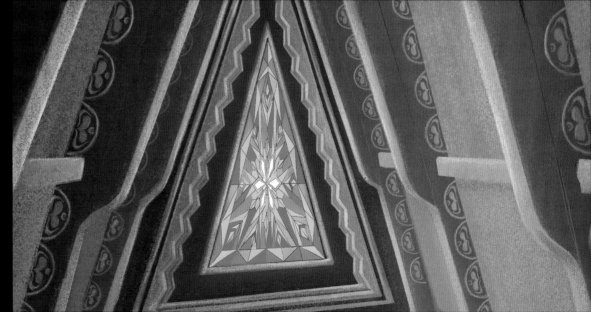

James Finch | Digital

Director Jennifer Lee adds, "When we put up a screening, if we don't have a song, we storyboard it with narration, rather than trying to write a scene to replace it."

The *Frozen* artists had to construct a film where it felt natural for the characters to sing, as they had in *Pinocchio* and *Lady and the Tramp*. Story artist Jeff Ranjo comments, "I like songs because there's a structure; you feel the rhythms and the movement, and you try to match the visuals to the musical piece. With a scripted scene, there's an outline and direction, but with music, it's more, 'What does this passage feel like? What's it going to look like in the movie?'"

Fellow story crew member Normand Lemay adds, "The songs are never going to stop this movie. It's almost as if the regular, real-time sequences are bridges to the songs."

But story artist Chris Williams cautions that a song sequence requires careful analysis: "You have to ask, 'Is the character actually singing in the reality that we've established? Is the character singing to herself, to other characters, or to the audience?' There's all these ways you can go."

Like most studio animated features of recent years, *Frozen* would be released in 3-D in many theaters. Although computer animation creates a dimensional world, release in the popular format required careful planning. Story artist John Ripa comments, "I've seen films in 3-D where a character essentially says, 'I've got my SPEAR and I'm poking it towards the camera!' It feels like a gimmick that pulls you out of the movie. The woods and mountains are going to add to the 3-D."

Head of story Paul Briggs agrees that 3-D will enhance the beauty and the menace of the snowy environment of the film: "I never think about 3-D while I'm boarding, but sucking the viewers into the film's environment is going to be really important. Immersing viewers in the blizzard at the end of the film will give them a sense of the struggle the characters are going through. It's not just a gimmick."

Creating snowstorms that were believable and carried the emotional impact Briggs describe was the job of the visual effects department. Effects supervisor Marlon West contrasts the challenges of creating 3-D snow with similar effects in drawn animation: "In 2-D, we talk about layers, things in front of and behind each

Lisa Keene | Digital

Cory Loftis | Digital

other. In stereo, the layers really have to integrate. In 2-D, it would be a layer of snow in front of the camera, or a layer of snow behind the characters. In this film, they're going to be immersed in snow."

"With 3-D, you have to make it spatially correct, otherwise as soon as the viewers put on their glasses they see the tricks," adds fellow supervisor Dale Mayeda. "Especially with snow, which gives you ten thousand visual cues of depth at every point on the screen."

Of all the challenges the artists faced on *Frozen*, perhaps the most daunting was the time in which it had to be made. The crew "cracked" the story in November 2012, barely a year before the film was slated for release. Some of the best-loved animated films of recent years were completed on short schedules, notably *Toy Story 2*, *Ratatouille*, and *Tangled*. Some artists feel a lack of time forces them to concentrate harder, to trust their initial impulses and avoid overthinking. But a short schedule also means late nights, overtime, and stress.

"We originally were slated for 2014, but we were asked if we could hit the fall of 2013 slot," Buck explains. "The studio has had many movies that felt like we'd never finish them on time, but we did. I'm excited; a little bit nervous, but excited."

"Having tight deadlines can stimulate creativity; it gives you a focus that you don't have with the luxury of time," adds Del Vecho. "But you want your story to be at a certain place before you start production; when you truncate the schedule, you overlap them. Fortunately, Jenn is very strong in story, editorial; Chris is very strong in production. Although they work closely together, when we need to keep things moving, we can divide and conquer."

Briggs sums up the attitude of the *Frozen* artists when he concludes, "I believe in the film. When you're working on something that's really emotional and powerful, it's inspiring. You get it done because you know it's going to be great."

> I can't think of a film I've worked on where everybody just chilled out while they worked. Even if we had two more years, we'd still be stressing about shots. It's what we signed up for when we wanted to be filmmakers.
> —Dan Lund, visual effects supervisor

Cory Loftis | Digital

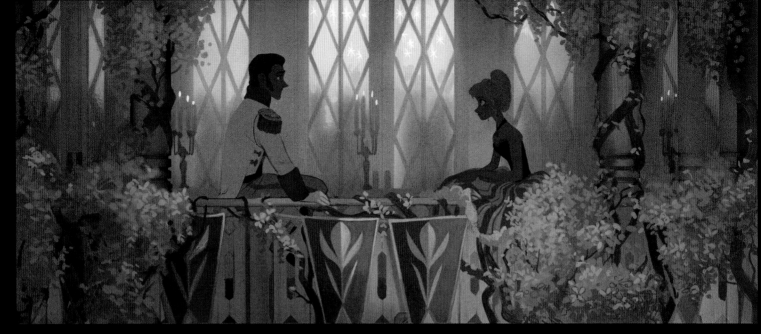

Cory Loftis | Digital

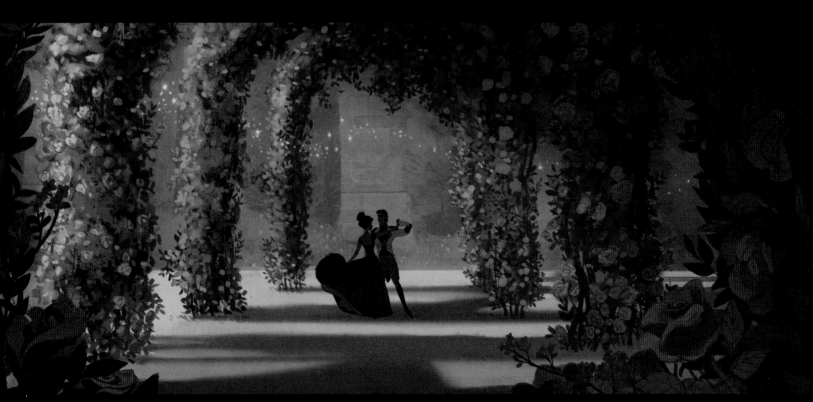

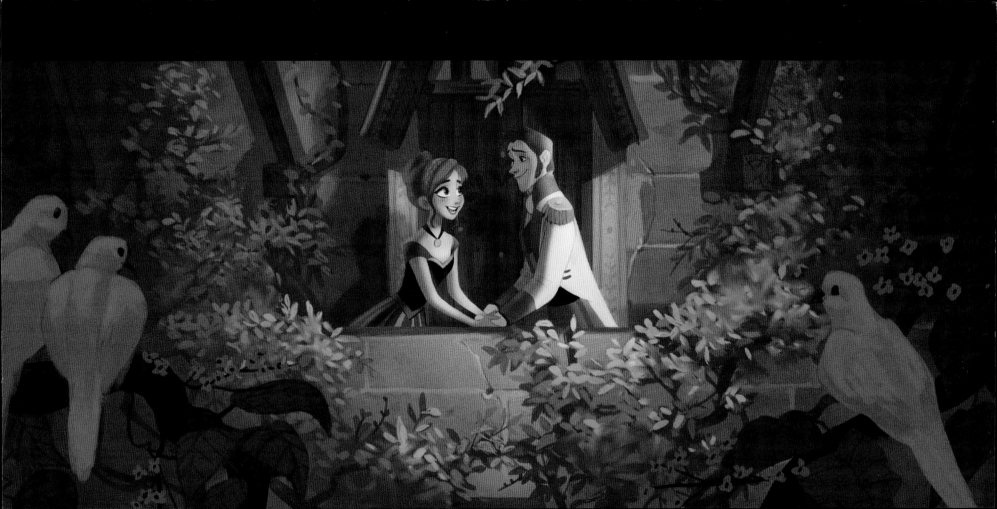

Tatar, Maria. *The Annotated Hans Christian Andersen*. New York: W. W. Norton, 2008.

ACKNOWLEDGMENTS

When Emily Haynes suggested doing this book, I was skeptical that it or *Frozen* could be completed in time. But the stunning preproduction artwork made me eager to write about the film, deadline or no. I was happy to work with Emily again, and the presence of some old friends on the production—Chris Buck, Michael Giaimo, and John Lasseter—made the prospect that much more enjoyable.

Thanks are due to the artists who took time out of a frantic schedule to answer my questions in interviews: Scott Beattie, Becky Bresee, Paul Briggs, Chris Buck, Carlos Cabrol, Clio Chiang, Peter Del Vecho, Lino Di Salvo, Jeff Draheim, Jim Finn, Mac George, Michael Giaimo, Jean Gillmore, Randy Haycock, Mark Henn, Mohit Kallianpur, Lisa Keene, Hans Keim, Jin Kim, Jon Krummel, John Lasseter, Brittney Lee, Jang Lee, Jennifer Lee, Normand Lemay, Cory Loftis, Dan Lund, Jason MacLeod, Steve Markowski, Dale Mayeda, Hyrum Osmond, Malcon Pierce, Jeff Ranjo, John Ripa, Tony Smeed, Josh Staub, Chad Stubblefield, Wayne Unten, Fawn Veerasunthorn, Marlon West, Chris Williams, David Womersley, Victoria Ying. Renato Lattanzi played a rapid-fire game of "schedule Tetris," despite an ever-shifting slate of meetings, ably assisted by Dara McGarry.

At the Disney Studio, Lella Smith and Mary Walsh ensure it's always a pleasure to work in the Animation Research Library. Fox Carney helped me research *The Snow Queen* with his accustomed diligence and puns. Rebecca Cline at the Disney Archives answered additional questions and solved at least one mystery.

Howard Green, without whom no animation book can be written, provided encouragement and lunches.

At Chronicle Books, capable assistance was provided once again by Beth Weber, Courtney Drew, Sarah Malarkey, Michael Morris, Lynda Crawford, Becca Boe, Lia Brown, and Beth Steiner.

Glen Nakasako at Smog Design created the book's beautiful design and elegant layout.

Taylor Jessen transcribed the interviews with a speed and accuracy that exceeded even his usual standard. My agent Richard Curtis oversaw the contract and dealt with my fussy e-mails. Happily, my friends remain willing to endure my jeremiads about writing: Julian Bermudez, Kevin Caffey, Alice Davis, Pete Docter, Eric and Susan Goldberg, Don Hahn, Dennis Johnson, Ursula LeGuin, Jef Mallett, John Rabe, Stuart Sumida. On the home front, thanks are once again due to Scott, Nova, Matter, and Typo, who continues to think he belongs on the keyboard.
—Charles Solomon

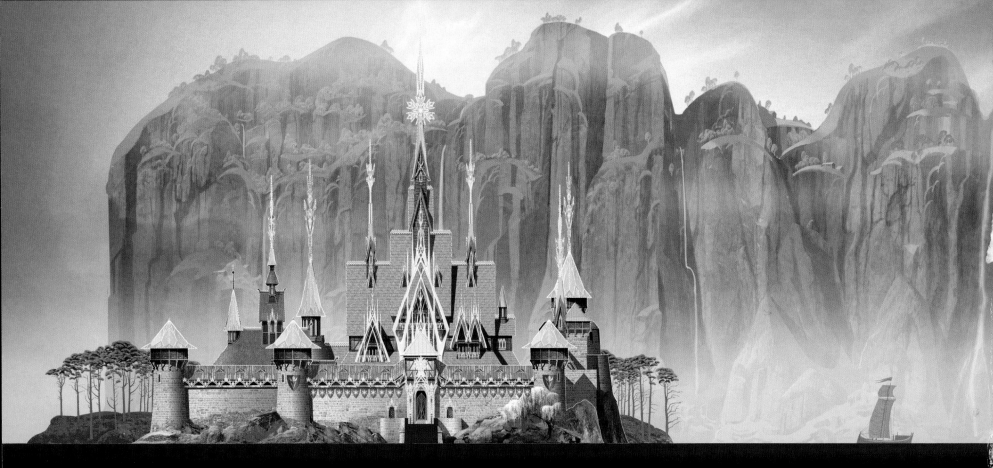

David Womersley | Digital